TOY BOATS

1870-1955

A Pictorial History

from the

FORBES Magazine Collection

by Jacques Milet and

Robert Forbes

Photography by Robert Forbes

with additional photography
by John Ehrenclou

Published by
CHARLES SCRIBNER'S SONS
New York

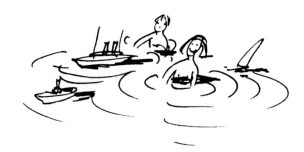

Typography: Trentypo Inc.
Printing: Princeton Polychrome
Fabergé p. 44 photographed by H. Peter Curran
paintings pp. ii, iii photographed by Otto Nelson
Drawing p. 103 by Chas. Addams; © 1950, 1978
The New Yorker Magazine, Inc.

Printed in the United States of America
Library of Congress Cataloging in Publication Data
Milet, Jacques, 1918-
Toy boats, 1870-1955.

Bibliography: p.
Includes index.
1. Ship models—Catalogs. 2. Tin toys—
Catalogs. 3. Forbes magazine—Art collections—
Catalogs. I. Forbes, Robert, 1949- joint
author. II. Ehrenclou, John. III. Title.
VM298.M5413 688.7'2 78-64678
ISBN 0-684-15967-8

Foreword

The toy traditions of our country have had more to do with horses, wagons, and later trains, cars, and planes than with boats. That's because agriculture was long our prime business, and there was always more land to be had to the West. The Atlantic Ocean was considered less an avenue of commerce than a barrier securing us against what Washington in his farewell address dubbed "foreign entanglements." Only along our seacoast did toy boats figure much in the artifacts of childhood.

So manufactured toy boats mostly came from the countries of Europe, where the Mediterranean, the English Channel and the oceans were prime paths to military, economic and cultural conquest.

With the advent of the Industrial Revolution and the subsequent marriage of steam and steel to ships, the seas were no longer confined to sails. The techniques of manufacturing were soon taken up by toy makers. In the field of toy boats the Golden Decades (1880s-1930s) of gleaming tin liners and lacquered grey battleships flourished.

These pages depict many of the best of those wonderful toys. These ships reflect the panache, the panoply that preceded World War I. The pomp and the pride of the Great Powers was shown in the commercial and naval fleets with which they dominated the seas and hence most of the globe.

Between World War I and World War II, children's boats rivaled the actual liners' rivalry for the Atlantic Blue Riband. Then came Hitler and World War II during which ever-bigger, swifter airplanes sank the great passenger and naval ships literally and figuratively.

———•••———

Why are old toy boats so relatively rare these days? Because they survive less than other toys for the very same reasons that real boats survive less long than most other manufactured things. Such toys were for playing with in the water. In the tub, recovering the sunk was easy, though resulting rust eventually took its toll. The most fun was sailing them on lakes and at seashores where recovery was more difficult and very frequently impossible.

As with the real ones, the more toy boats did their thing, the less likely they were to survive.

Testing the seaworthiness of a Fleischmann gunboat. (See back cover for test results.)

Boats and the sea always had strong appeal to me. The first time I sailed on an ocean monarch was at the age of seven, aboard the *Aquitania*. My Scotland-born father loved to revisit the Aberdeenshire scenes of his youth and so most every other summer until WW II our family sailed to Southampton, or sometimes directly to Glasgow by the Anchor Line. After Scotland, we would go on to Europe and sail home from Le Havre or Marseilles. That port was served by the long-famed, now gone Dollar Line, named for the Robert, not the buck. He was a great friend of my father's and I vividly remember meeting this brogue'd patriarch of globe-circling liners on numerous occasions.

On one crossing I took a toy boat and with my brothers' aid lowered it–secured by a strong twine–the long way from rail to sea. We intended that this toy liner, too, should make the Atlantic crossing. It survived departure from the dock, but within a few minutes of our being underway the bashing soon saw it underway to Davey Jones' locker.

Anyway, toy boats in the Forbes family were more prized than electric trains or other playthings. We were forever sailing them in nearby brooks and streams and in summers on lakes or oceans. Not a one survived to be part of this collection. But the memory of them and the joy of them account for its formation.

As can be seen in the John Koch painting (opposite p. iii) done to mark our tenth anniversary, our children too grew up with toy boats. One of them, Robert, has had as much fun as his father assembling this collection, and he has brought to it a knowledge of the subject and a scope that I never had. It's reflected in his imaginative photographs involving submerged submarines, toy lighthouses, "shell flashes" beside battleships and the wonderful juxtaposition of people, rowboats, docks and toy boats.

This volume will probably be seen by more people than will see the collection. Very likely it will survive longer than the collection, so we've tried to make it convey the flavor, the fun and the significance of these lovely toys. The things of childhood have a lasting impression throughout one's life. If they are playwithable, imaginative and beautiful, it's important.

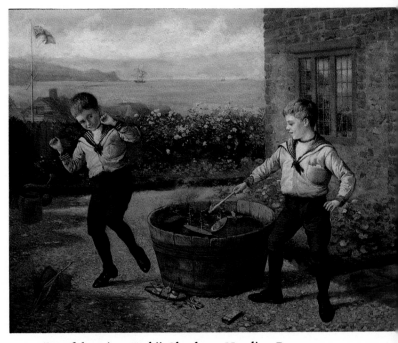

"Trafalgar in a Tub" Charlotte Harding Brown late 19th century.

"The Malcolm S. Forbes Family" John Koch 1956 ☞

ii

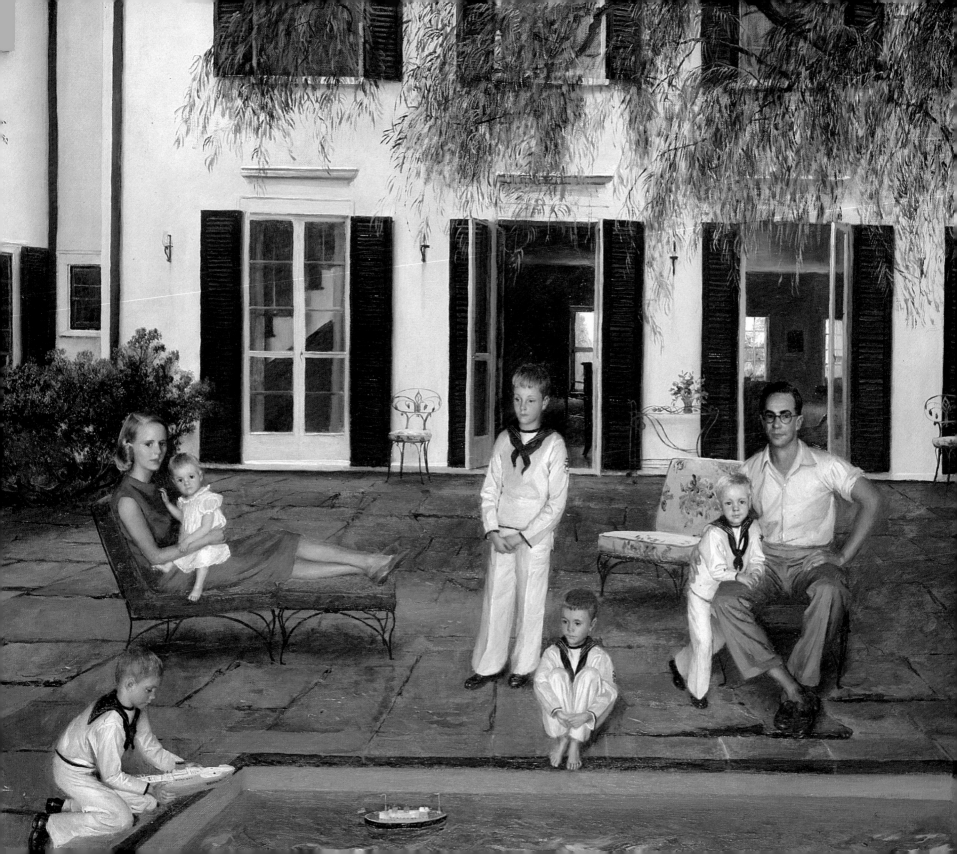

Acknowledgements

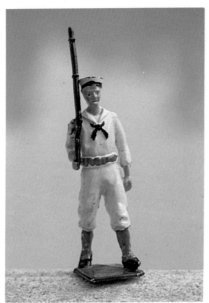

Seen here his actual size—2" 5 cm. —this Britains Ltd. sailor is often included in photographs to give scale.

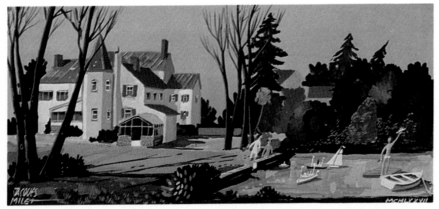

One frosty morning at the "quarry" by the Casey house, the *Antonio* (see p. 64) started taking on water, and before we could rescue her, she went down. Icy waves notwithstanding, I plunged in and managed to salvage our sunk friend. Fortunately, it was later I found out about the snakes and snapping turtles . . .

Toy Boats are different from model boats because a toy is manufactured in numbers while a handmade model is unique. With one or two exceptions, all the boats in this collection are toys, with dates and manufacturer assigned where possible.

In collecting, the piece in best condition is most desirable, but with toys this guideline is contrary to the very purpose of a toy. It's meant to be played with, not left in its box up in the attic; so in this catalogue we often show the boats in their natural habitat, as playthings. By collecting and cataloguing these toy boats we hope to preserve for future generations the chance to see what past generations played with. As Jacques says, "It is a delight to receive a caress from the world of a child." And children, we know, can be ageless.

Warm thanks to: *David Pressland*, whose book *The Art of the Tin Toy* is already a standard of style, simplicity and information; *Ron McCrindell*, whose passion for toy boats has inspired many; *Count Giansanti-Coluzzi*, a collector and source of help; *Dr. Baumer*, of Switzerland, whose hospitality and knowledge were extended warmly; *M. Meich*, of France, an expert restorer and source of technical information.

The boats and much help in research have come from all over: *Roger Paul*, who gave us the first encouraging boost of half a dozen boats; *Bob, Gene and Jay Lowe* of Toonerville Junction, whose eyes, ears and expertise we'd be lost without; *Van Dexter* of Second Childhood; *Anthea Knowles*; *Bill Holland*; *Dale Kelley's Antique Toy World*; *Mel Roberts*; *Joachim Seidel*; *Ken Harmon*; and many others.

The old catalogue pages come from our own originals; from *David Pressland, Dave Davison, Barney Barenholtz* and *John Hohenberger*; and a special thanks to *Adrien Maeght* for permission to reproduce certain catalogue pages from *Les Bateaux Jouets*.

For the book itself, thanks to *Image Photographic* for their constant excellence in the darkroom; *John Ehrenclou* for his delightful photographic aid; *Margaret Kelly* for undaunted filing; *Dennis Fleck* for fine restorations and general help; *Bill Sumfest* for a superb layout; *Harold Simon* of Trentypo for optimism and practicality in giving the book life.

And for the photographic locations, thanks to the *James Casey and Anthony Villa families* for the use of their water-filled quarry (see left); the *Somerset Lake and Game Club* for kind permission to use Blair's Lake; and *Jacques* for his enchanting painted backdrops.

Robert Forbes

Contents

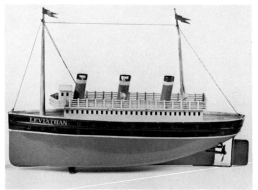

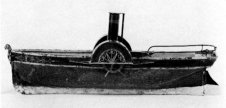

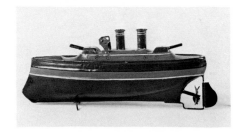

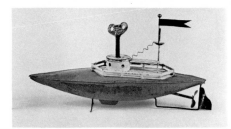

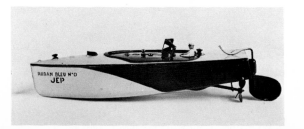

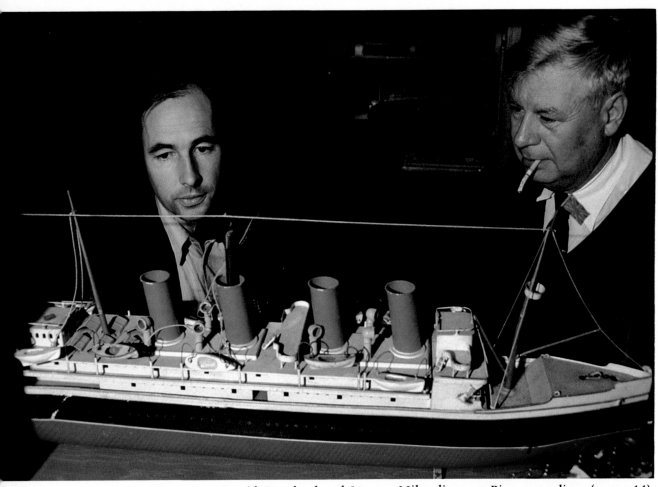

David Pressland and Jacques Milet discuss a Bing ocean liner (see p. 14).

Radiguet & Massiot warship (see p. 71).

Introduction

I have collected tin mechanical toys all my adult life and have derived much pleasure and made many friends through their study and collection. Many early tin toys are attractive visual objects that not only have a naive sculptural quality but also charming paintwork and fascinating mechanisms. They are also a very succinct and easily understood statement of the period in which they were made, reflecting the changing fashions, inventions and pastimes of a rapidly changing world.

Tin toys were first made at the beginning of the industrial revolution and represented the first trains, steam engines, iron boats and carriages of that period. These early toys were artisan creations but as the Nineteenth Century progressed and technology advanced toy factories appeared so that by the turn of the century complex train sets, stunning boats and cars were being produced in considerable quantity in both America and Europe.

These tin toys were objects to be played with rather than be looked at and consequently the vast majority were destroyed or damaged by their youthful owners. All Nineteenth Century and early Twentieth Century toys are now rare objects that many people today have never seen. Some years ago I heard that *Forbes Magazine* was putting together a collection of toy boats and later I was privileged to visit it. Among the over 300 *Forbes* vessels are many large and important early toy boats, but for perspective, it also contains many more recent and mundane toys that give a balance of light and shade so essential to any collection. It is much easier for a child or indeed an adult seeing an object for the first time to relate to it if it is or has been mildly obtainable and later to progress to understand and acquire the accepted best in that particular field.

There are few museums in the world that have a meaningful collection of toy boats and it gives me great pleasure to know that a wider audience will be able to appreciate the charm and diversity of the early toy boats through this catalogue and exhibitions. If even a small amount of the pleasure that all associated with this catalogue have derived from these toys is shared by the reader then I am certain that one of the prime objects of this catalogue will have been fulfilled.

David E. Pressland
London May 1978

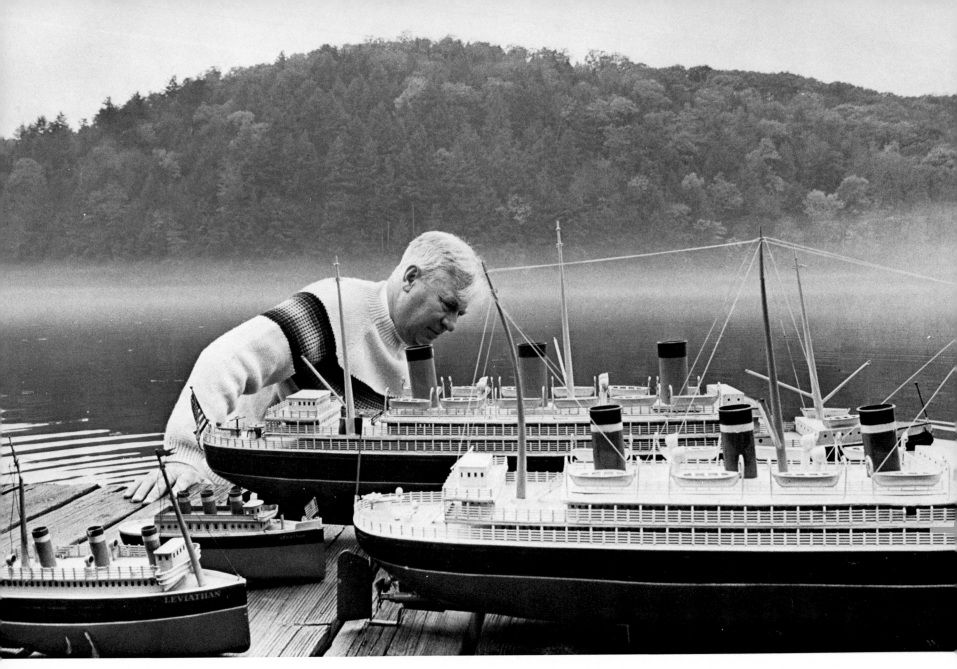

LE BLAIR'S LAKE DANS LE NEW JERSEY
PAR UNE MATINÉE BRUMEUSE AUTOMNE
DE MAGNIFIQUES TRANSATLANTIQUES . . .
UN HOMME HEUREUX

Octobre 1977

OCEAN LINERS

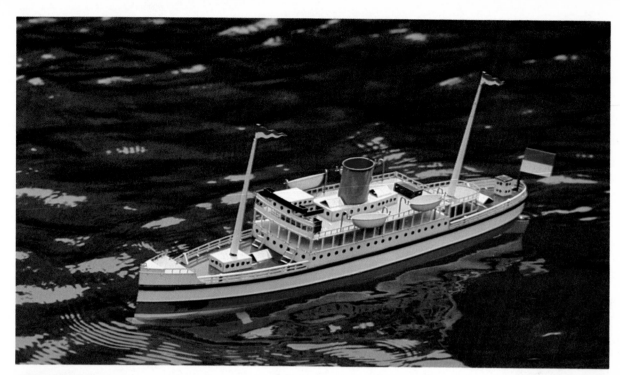

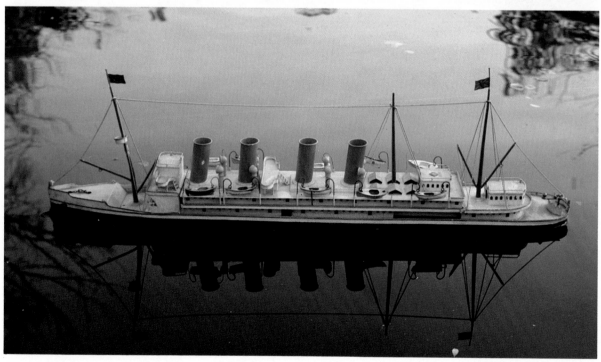

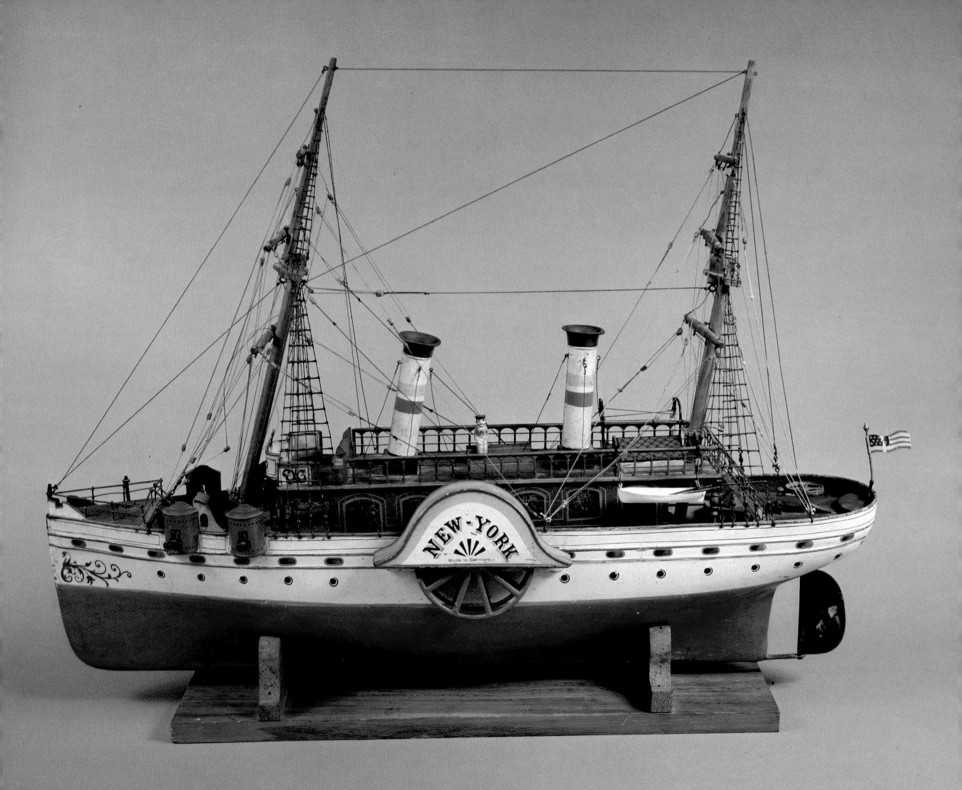

Marklin

FIRST SERIES 1898-1920

In the history of men, and oceans, the development of the glamorous transatlantic passenger liner is quite recent. Aside from early attempts at large-scale sea travel, such as Brunel's *"Great Eastern,"* built in 1858, it was not until the turn of the century that the greatest floating palaces were launched and quickly became legend. These naturally captured the imagination of the masterful German toymakers of Nuremberg who started producing splendid toy imitations of these ships. Founded in 1859, the firm of Marklin, the most famous of these, produced a top-quality line of trains as well as a popular fleet of boats.

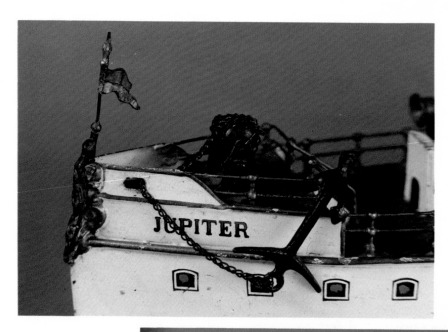

New York 1904 31-1/2" 80 cm. The *New York* was in a toy museum for years, a reason for its fine condition; ironically, though, to fit onto the shelf there, the other paddlewheel and casing were removed and consequently lost. Note the passenger and tiny oars which are original, while the masts and rigging are not.

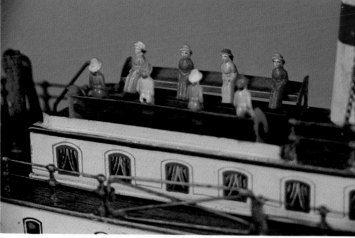

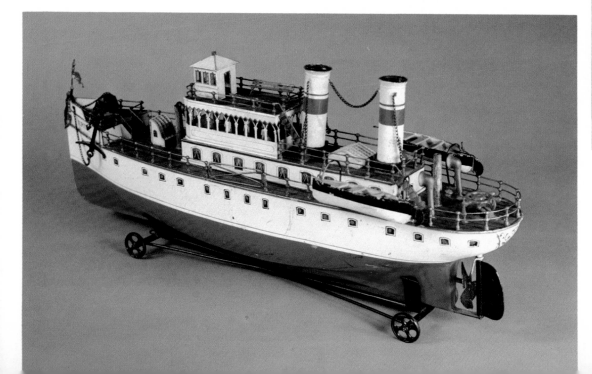

left and above: *Jupiter* 1909 27" 69 cm. This well-preserved ship still has all passengers, its original wheel carriage, and even the pennant in the bow. Marklin named most of their boats and provided flags appropriate to the market the boat was intended for. According to the catalogue featuring this boat, the clockwork motor lasted 12 minutes, the steam for 18.

3

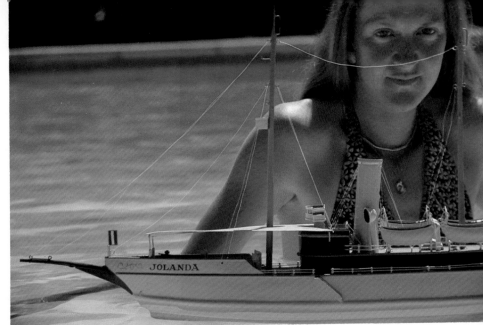

Baltimore 1900 30" 76 cm.; *Jolanda* 1904 24" 61 cm.; *St. Paul* 1904 27" 69 cm.

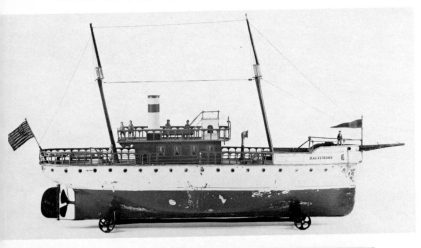

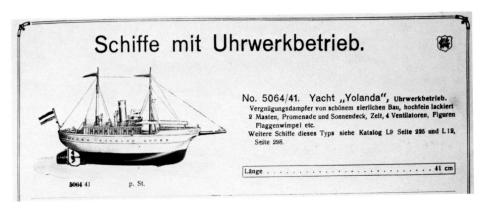

As seen above left, the *Jolanda* was in terrible shape. Restoration we felt would save the ship from further destruction. Careful work has rendered the yacht a delightful working toy now, above. (See p. 26 for a discussion of restorations.)

The *Baltimore*, left and below, is the earliest of these Marklin ships and was available with a propeller or as a sidewheeler.

The *St. Paul* is the American market version of the *Jupiter*.

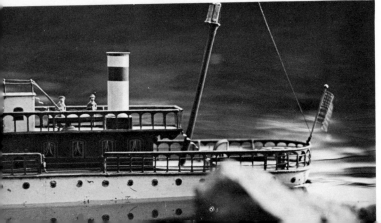

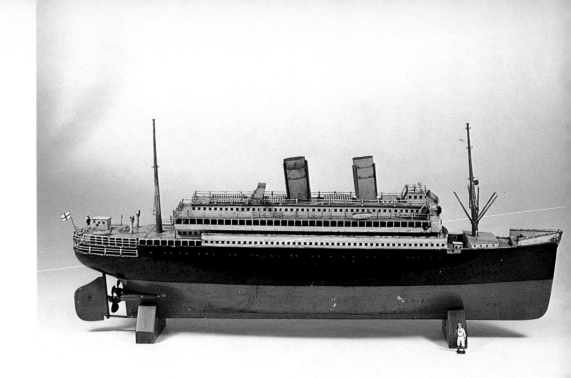

1910 38" 97 cm.

Around 1900 they introduced their First Series of ocean liners of three and four funnels that stretched up to 38-1/2" 98 cm. for the largest model. The price for this giant was a whopping 200 gold francs, and was available with a choice of three types of propulsion: a twenty-minute clockwork motor; a one-hour steam engine; or a six-hour electric motor. Generally, these Marklin boats sported two masts with stays, two propellers, and were minutely detailed: ten removable lifeboats, a capstan that moved, a steering bridge, and a lead anchor on a chain. The hulls were strong and well-weighted with lead, meticulously painted and were provided with a wheel carriage for display in the playroom. Marklin also included a complement of fine hand painted passengers, ship officers and deck hands. The superstructure came off in one piece, giving easy access to the motors, drive shafts and gears.

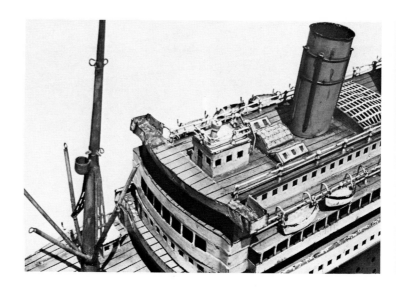

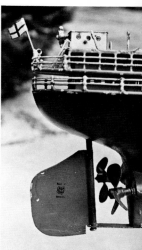

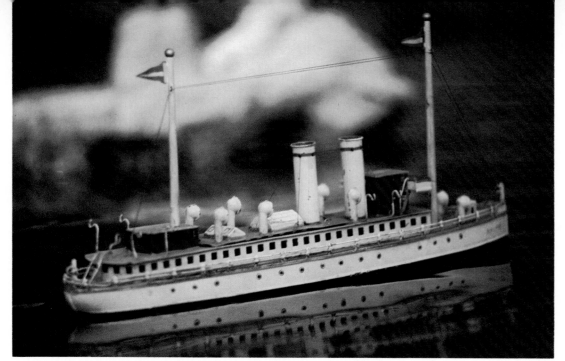

Spree 1912 16-1/2" 42 cm.

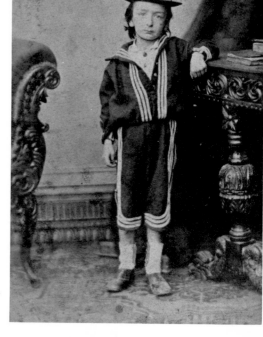

This forlorn captain obviously needs a Marklin ship to command.

S.S. Mauretania,
the Fastest Steamer
of the World

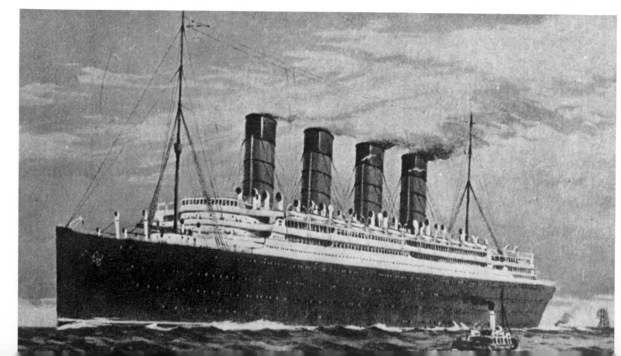

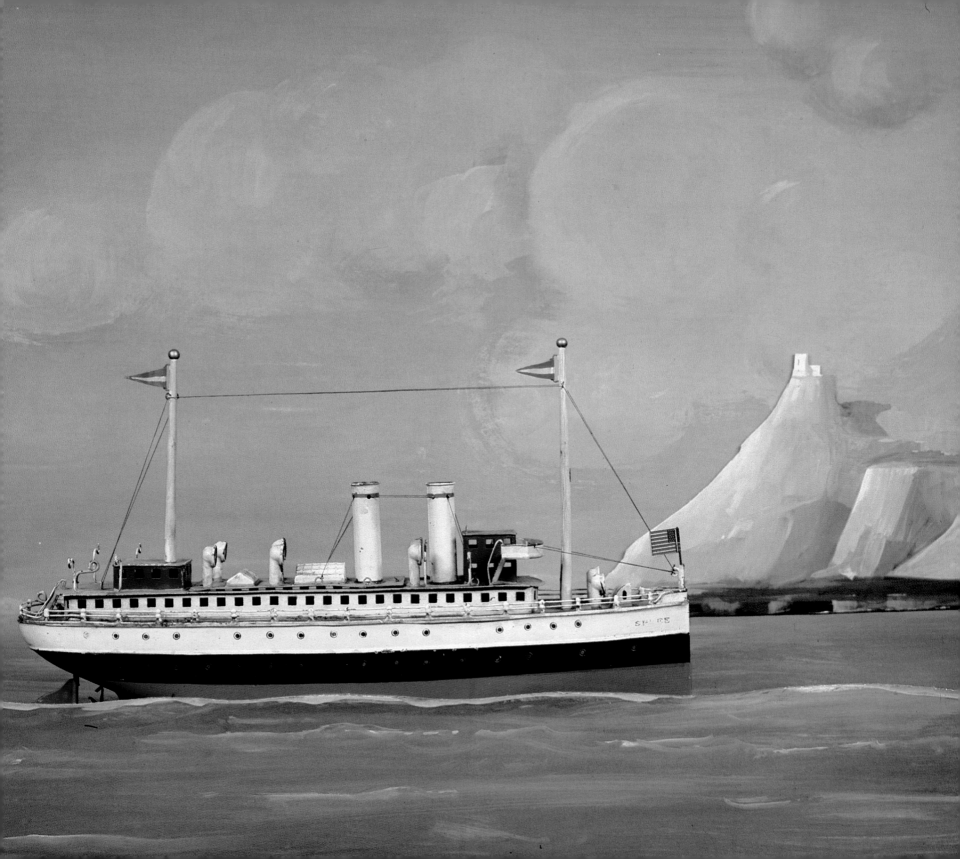

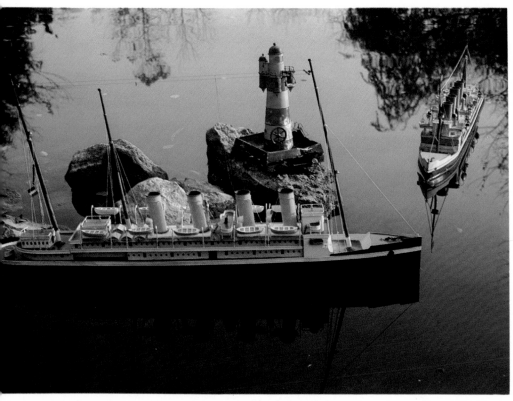

Two Bing sister ships with a lighthouse from Doll & Co.

Bing

FIRST SERIES 1890-1910

Gebrüder Bing, also of Nuremberg, was founded in 1886 and competed heavily with Marklin for a burgeoning toy market that was thrilling children all over the world. We know from a Bing catalogue of 1902 that their entries into the liner race ranged in size from 25–29-1/2" 64–75 cm. long, had up to three masts, two propellers, two stacks and six lifeboats but came only with a clockwork motor.

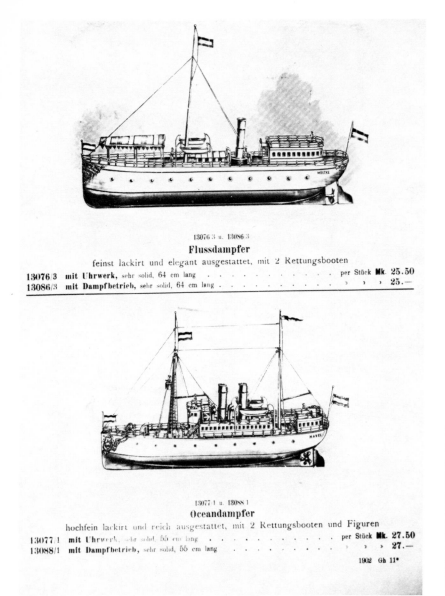

Ocean=Dampfer.

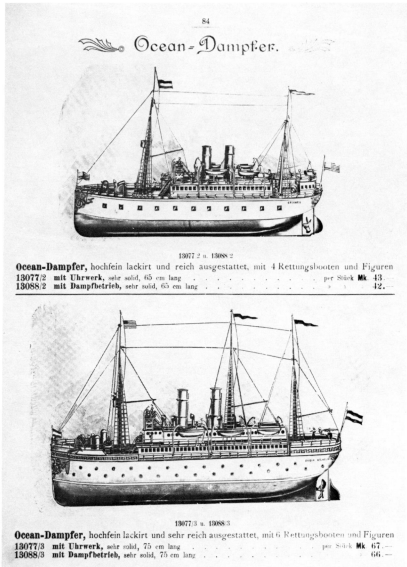

13076/3 u. 13086/3

Flussdampfer

feinst lackirt und elegant ausgestattet, mit 2 Rettungsbooten

13076/3 mit Uhrwerk, sehr solid, 64 cm lang per Stück Mk. 25.50
13086/3 mit Dampfbetrieb, sehr solid, 64 cm lang » » » 25.—

13077/1 u. 13088/1

Oceandampfer

hochfein lackirt und reich ausgestattet, mit 2 Rettungsbooten und Figuren

13077/1 mit Uhrwerk, sehr solid, 55 cm lang per Stück Mk. 27.50
13088/1 mit Dampfbetrieb, sehr solid, 55 cm lang » » » 27.—

1902 Gh 11*

13077/2 u. 13088/2

Ocean-Dampfer, hochfein lackirt und reich ausgestattet, mit 4 Rettungsbooten und Figuren

13077/2 mit Uhrwerk, sehr solid, 65 cm lang per Stück Mk. 43.—
13088/2 mit Dampfbetrieb, sehr solid, 65 cm lang » » » 42.—

13077/3 u. 13088/3

Ocean-Dampfer, hochfein lackirt und sehr reich ausgestattet, mit 6 Rettungsbooten und Figuren

13077/3 mit Uhrwerk, sehr solid, 75 cm lang per Stück Mk. 67.—
13088/3 mit Dampfbetrieb, sehr solid, 75 cm lang » » » 66.—

These early catalogue pages illustrate Bing's very rare First Series of toy liners, which were comparable to the most beautiful Marklins of the time. The only boats that still exist from the period are often heavily restored.

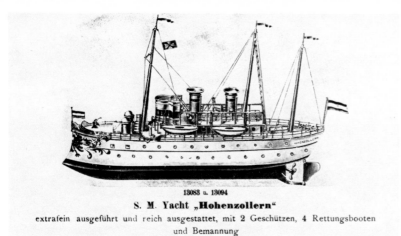

13083 u. 13094

S. M. Yacht „Hohenzollern"

extrafein ausgeführt und reich ausgestattet, mit 2 Geschützen, 4 Rettungsbooten
und Bemannung

The *Hohenzollern* was the Kaiser's yacht. It could be
converted into a gunboat if needed. This yacht from the
First Series certainly rivalled any from Marklin. Interest-
ingly, Queen Elizabeth II's Royal Yacht *Brittania* is
convertible to a hospital ship if necessary.

SECOND SERIES 1910-1914

These boats had an allure and a finish that was still superb but
they were basically more simple than their Marklin coun-
terparts. Second Series boats range from 7" 18 cm. to 37" 94 cm.
and cost from 9 to 144 Swiss Francs. Electric motors were
introduced at this time.

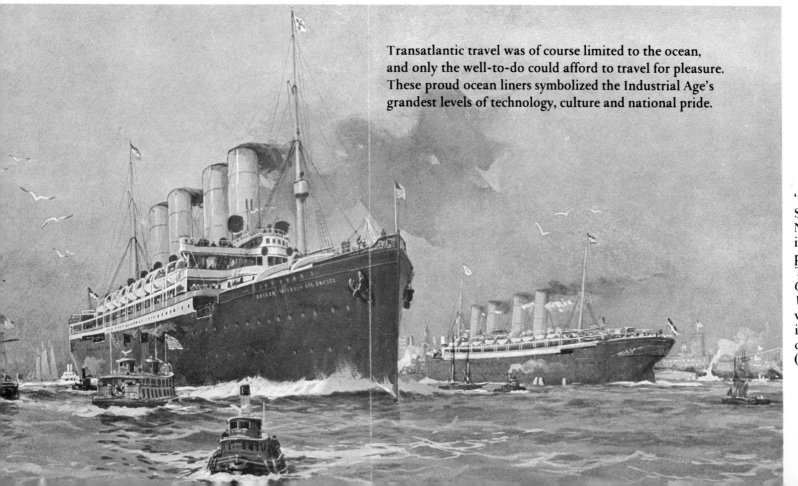

Transatlantic travel was of course limited to the ocean,
and only the well-to-do could afford to travel for pleasure.
These proud ocean liners symbolized the Industrial Age's
grandest levels of technology, culture and national pride.

"Twin Screw Express
Steamers of the
Norddeutscher Lloyd
in the Hudson River
passing each other."
The *Kronprinzessin
Cecilie* and the *Kaiser
Wilhelm der Grosse*
were an obvious
inspiration to the
designers at Bing.
(See next page.)

13

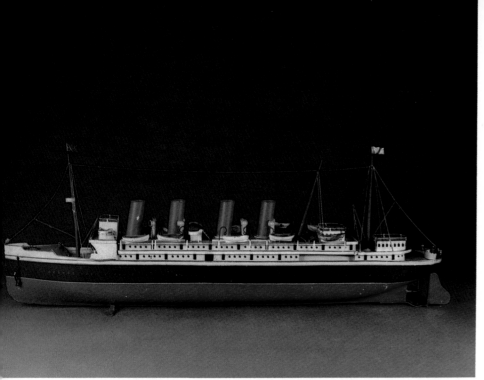

1912 40" 102 cm.

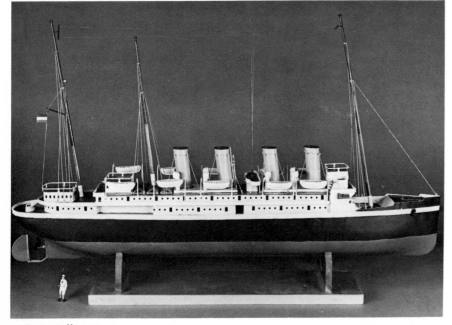

1912 40" 102 cm.

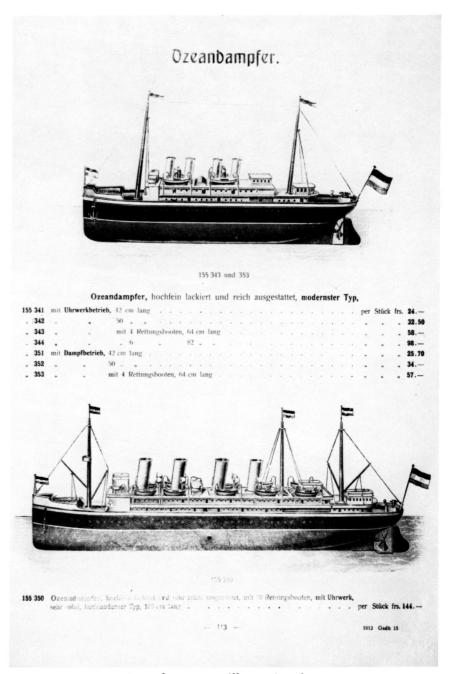

Ozeandampfer.

155 343 und 353

Ozeandampfer, hochfein lackiert und reich ausgestattet, **modernster Typ,**

155 341	mit **Uhrwerkbetrieb**, 42 cm lang		per Stück frs.	**24.—**	
„ /342	„ „ 50 „		„ „	**32.50**	
„ 343	„ mit 4 Rettungsbooten, 64 cm lang		„ „	**58.—**	
„ 344	„ „ 6 „ 82 „		„ „	**98.—**	
„ 351	mit **Dampfbetrieb**, 42 cm lang		„ „	**25.70**	
„ 352	„ „ 50 „		„ „	**34.—**	
„ 353	„ mit 4 Rettungsbooten, 64 cm lang		„ „	**57.—**	

155 350

155 350 Ozeandampfer, hochfein lackiert und sehr reich ausgestattet, mit 10 Rettungsbooten, mit Uhrwerk, sehr solid, hochmoderner Typ, 103 cm lang per Stück frs. **144.—**

— 113 —

1912 Gsdh 15

A catalogue page illustrating these two boats from Bing's Second Series.

14

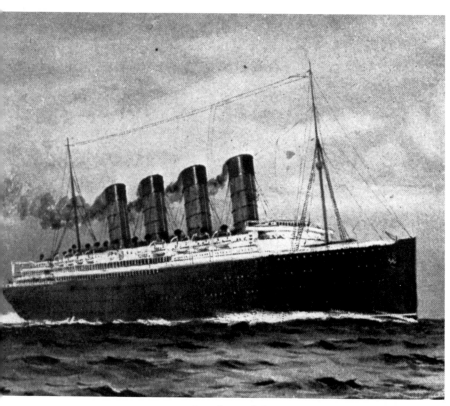

Another of the great liners, the *Lusitania*.

Antriebs-Mechanismen für Schiffe
auf Normal-Bodenplatten, so dass Auswechslung der einzelnen Mechanismen untereinander möglich.

Antriebs-Mechanismus mit Uhrwerkbetrieb für Schiffe
(Uhrwerk mit starker Feder).

10/9151/1	13,5 cm lang, 4,8 cm breit, 9 cm hoch	per Stück Mk.					
/3	17,5	„	„	7,5	„	13	„ „ „
/4	18	„	„	7,5	„	15	„ „ „

10/9151

Antriebs-Mechanismus mit elektrischem Betrieb für Schiffe
mit Magnetmotor und Elementgehäuse (ohne Element)

10/9152/1	13,5 cm lang, 4,8 cm breit, 8,5 cm hoch	per Stück Mk.					
/2	16	„	„	5,5	„	8,5	„ „ „
/3	17,5	„	„	7,5	„	8,5	„ „ „

10/9152

Antriebs-Mechanismus mit Dampfbetrieb für Schiffe
mit Messingkessel, oszillierendem Zylinder und massivem Schwungrad

10/9153/1	13,5 cm lang, 4,8 cm breit, 8 cm hoch	per Stück Mk.					
/2	16	„	„	5,5	„	8	„ „ „

10/9153

Einzelne Uhrwerke für Schiffe
äusserst solid gearbeitet

10/9154/1	10 cm lang, 4 cm breit, 3,5 cm hoch	per Stück Mk.					
/2	13	„	7	„	7,5	„ „ „	
/3	16	„	9,5	„	15	„ „ „	

10/9154

Uhrwerkschlüssel für Schiffe

10/9144	Vierkant-Oeffnung	2,4×2,4 mm, Schaftlänge 35 mm	per Stück Mk.			
10/9147	„	2,4×2,4	„	„	62	„	„ „
10/9145	„	2,8×2,8	„	„	40	„	„ „
10/9148	„	2,8×2,8	„	„	62	„	„ „
10/9146	„	3,2×3,2	„	„	44	„	„ „
10/9149	„	3,2×3,2	„	„	62	„	„ „

— 56 —

This Bing catalogue shows the various means of propulsion available at one time. Very few models were equipped with the electric motor, and many of the boats fitted out with steam engines sadly disappeared for inherent reasons, such as overheated boilers.

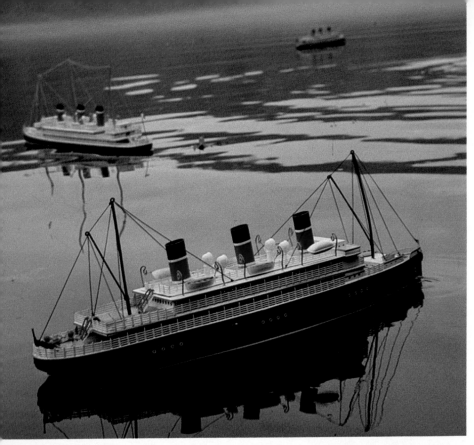

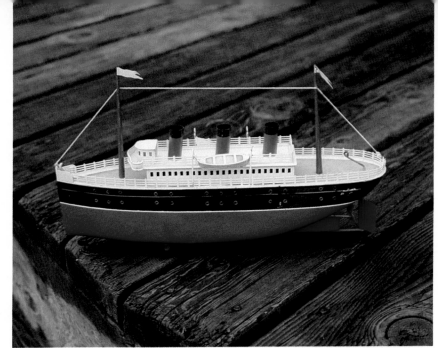

1920 15" 38 cm.

☛ foreground: *Bremen*
1912-1920 26" 66 cm.

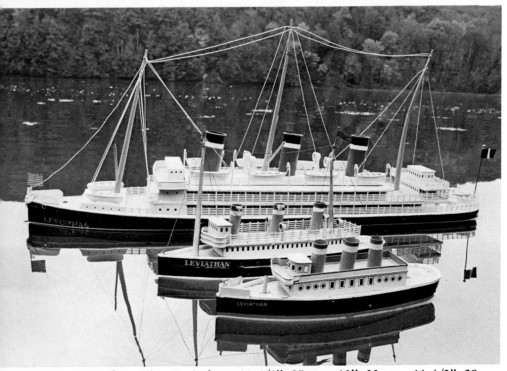

Three Bing *Leviathans* 10-1/2" 27 cm.; 13" 33 cm.; 11-1/2" 29 cm.

16

THIRD SERIES 1914-1928

The Third Series liners were produced in great numbers and though rare, do appear occasionally. The big ones, up to one meter long, are among the most pleasant toy boats ever made: their lines are well-proportioned to their size and evoke that delicious sense of grand delusion in miniature.

These are first and foremost toys, not just replicas, and therein lies the delight. The suspension of disbelief is greatly heightened with these boats because they are not misinterpreted as direct imitations of real boats. They are instead real *toy* boats, and with them come their own real world for children.

The smallest of them was available at 4-3/4" 12 cm. while the larger ships had two propellers, three funnels and fourteen lifeboats and came with either steam or clockwork engines.

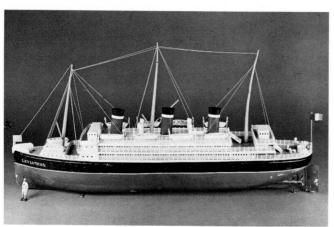

Leviathan 1914-1920 33" 84 cm.

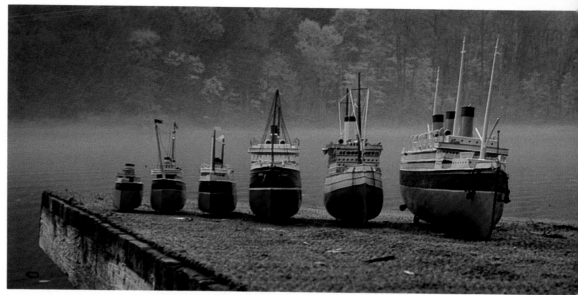

A beautiful series of Bing liners with a Fleischmann of the same period (second from right).

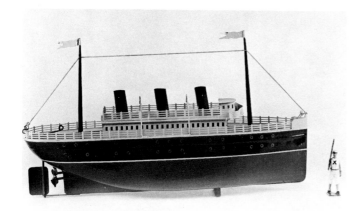

1920 15" 38 cm.

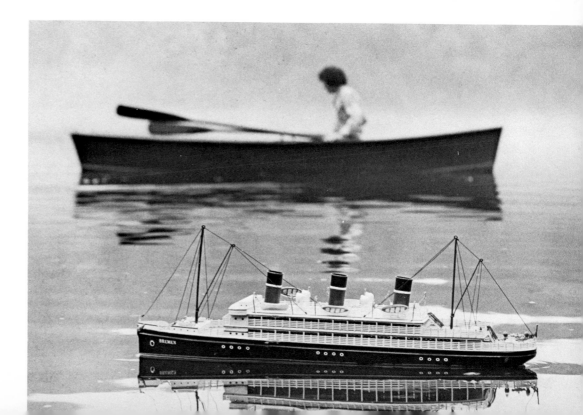

Two catalogue
pages with boats
from Bing's
Third Series.

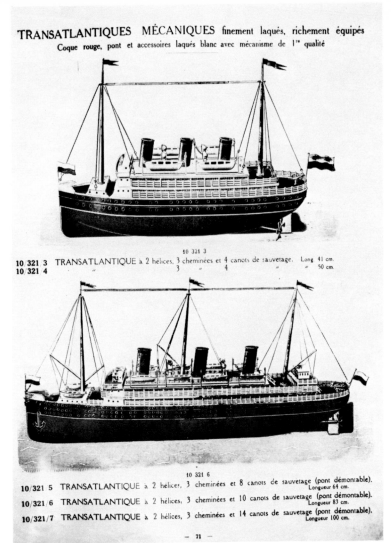

TRANSATLANTIQUES MÉCANIQUES finement laqués, richement équipés
Coque rouge, pont et accessoires laqués blanc avec mécanisme de 1ʳᵉ qualité

10 321 3

10/321 3 TRANSATLANTIQUE à 2 hélices, 3 cheminées et 4 canots de sauvetage. Long. 41 cm.
10/321 4 " " " " 3 " " 4 " " " " 50 cm.

10 321 6

10/321 5 TRANSATLANTIQUE à 2 hélices, 3 cheminées et 8 canots de sauvetage (pont démontable).
 Longueur 64 cm.
10/321 6 TRANSATLANTIQUE à 2 hélices, 3 cheminées et 10 canots de sauvetage (pont démontable).
 Longueur 83 cm.
10/321 7 TRANSATLANTIQUE à 2 hélices, 3 cheminées et 14 canots de sauvetage (pont démontable).
 Longueur 100 cm.

— 71 —

Schiffe
in bester Ausführung und Ausstattung,
mit solidem Uhrwerk, ff. lackiert.

Ozeandampfer.

10/31/1 10/31/2

10/31/1 Ozeandampfer, feinst lackiert, mit 2 Kaminen, 18 cm lang per Stück Mk.
 /2 do. " " " 2 " 19 " " " " "

Ozeandampfer.

10/31/3 10/31/5

10/31/3 Ozeandampfer, feinst lackiert, mit 3 Kaminen, 22 cm lang per Stück Mk.
 /4 do. " " " 4 " 26 " " " " "
 /5 do. " " " 4 " 32 " " " " "

— 50 —

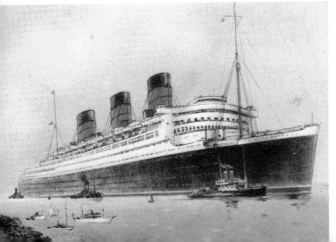

The *Queen Mary* as she looked before World War II.

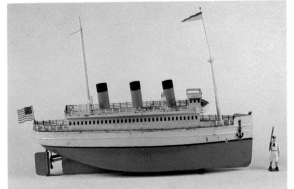

1920 15" 38 cm.

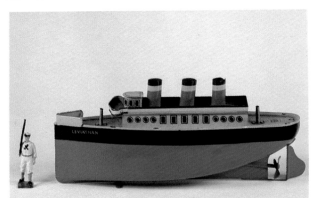

Leviathan 1920 10-1/2" 27 cm.

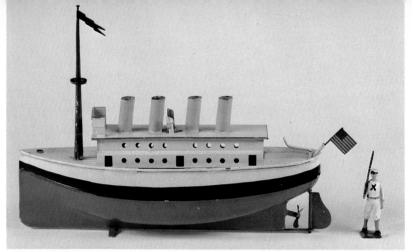

1920 15" 38 cm.

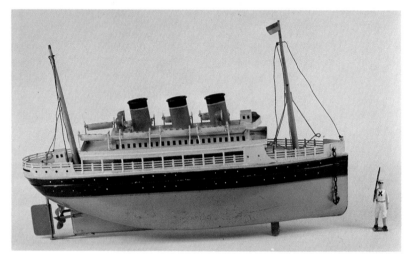

1925 13" 33 cm.

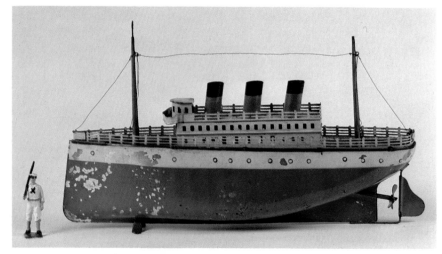

1910 10-1/2" 27 cm.

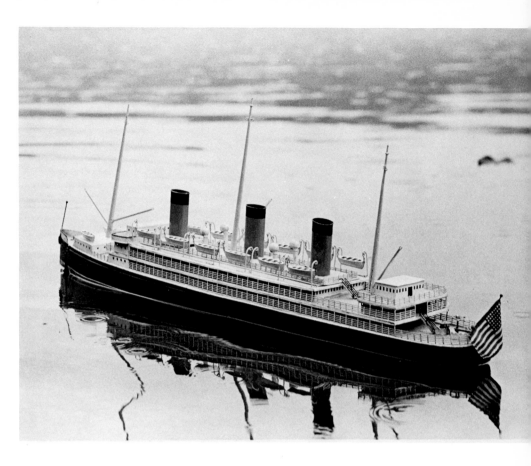

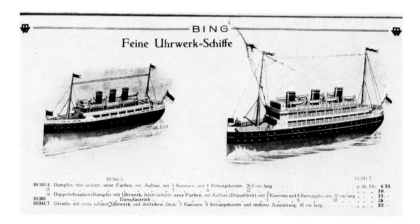

above and overleaf: 1914-1920 40" 102 cm.

19

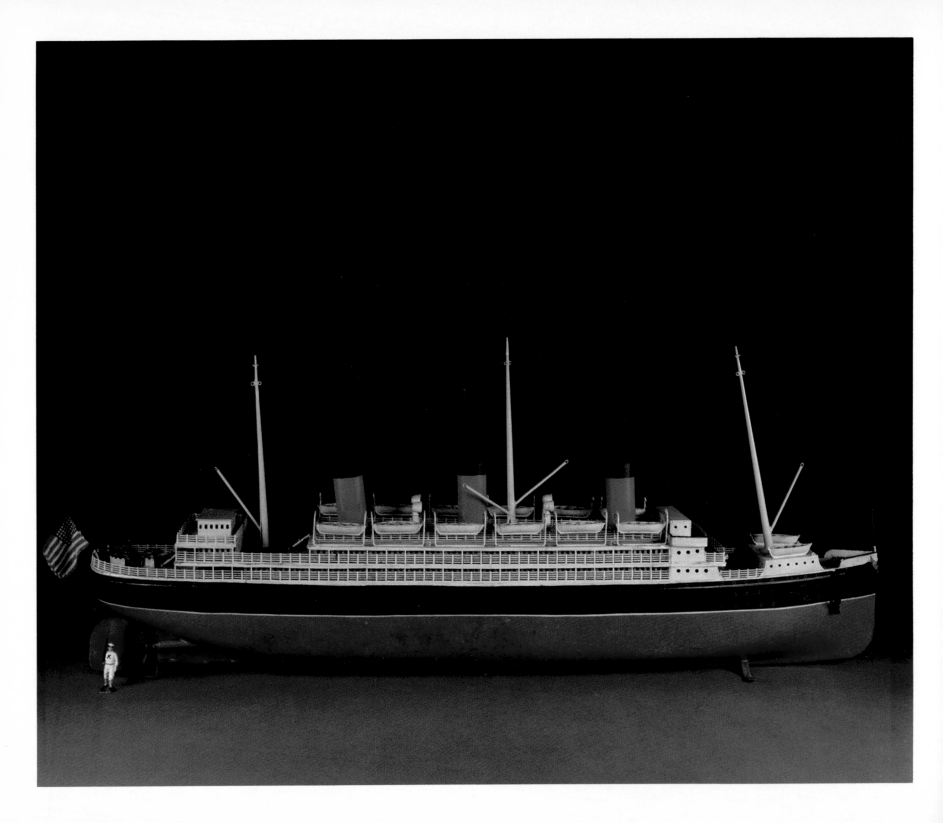

Fleischmann

Founded in 1887 in Nuremberg, the firm of
Fleischmann and Company started producing
toy liners around 1900, taking directly the
design of such Norddeutscher-Lloyd ships such
as the *Bremen* and *Vaterland*. Unfortunately,
there are no known catalogues from this period.

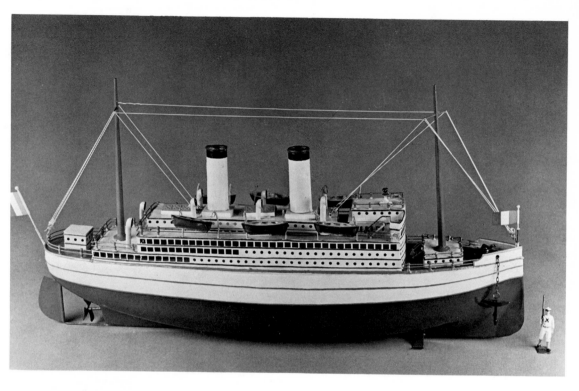

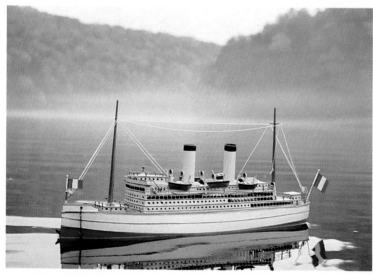

1910 24" 61 cm.

This beautiful though repainted boat was the object of a
lot of discussion among the experts. The toy boat collector
Armand Garnier has one of these and according to him it is
definitely a Fleischmann, even though the trademark is gone.
According to Ron McCrindell the tremendous similarities
between Fleischmann and Carette often make attribution
difficult.

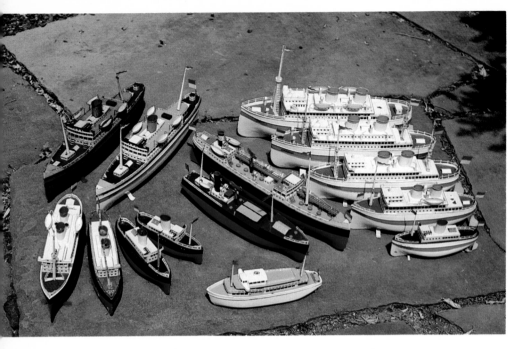

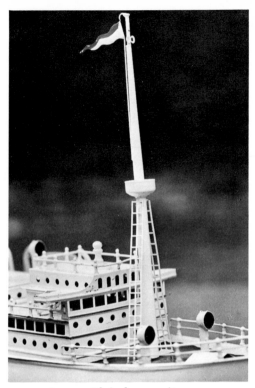

Larger Fleischmann liners
sport a very distinctive mast.

front left: 16-1/2" 42 cm.;
11" 28 cm.; 8-1/2" 22 cm.;
9" 23 cm.;
front center: 11" 28 cm.;
rear left, both: 21" 53 cm.;
mid-center, left: 16" 41 cm.;
mid-center, right: 13" 33 cm.;
front to rear, right: 9" 23 cm.;
13-1/2" 34 cm.; 17" 43 cm.;
18" 46 cm.; 19-1/2" 50 cm.

While most of these models
were introduced by the Thirties,
the condition of these boats
indicates they were made
after WW II.

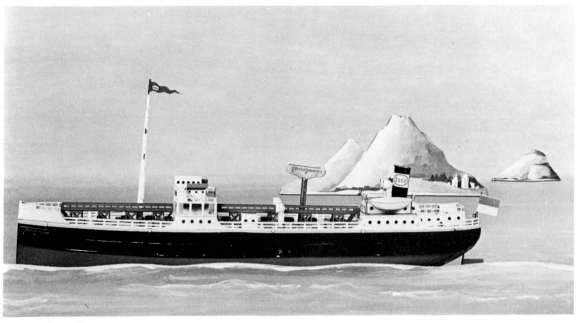

1955 21" 53 cm.

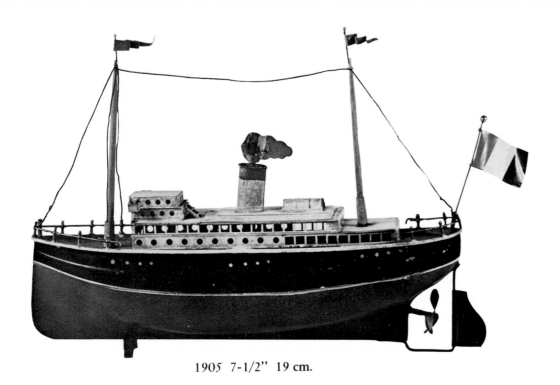

1905 7-1/2" 19 cm.

Although the smokestack key is a popular Carette feature, some Bing models of the period used it as well. The Nuremberg toy makers were free with each others' ideas and designs, thus making later identification difficult.

Carette

George Carette was a Frenchman who married a German and went to Nuremberg where he founded in 1886 the firm of George Carette and Company. He worked in direct collaboration with Bing and that is why many of Carette's boats resemble at first those of Bing. In England many Carette toys were sold through the famous Basset-Lowke stores.

From Carette came an extensive selection of graceful liners that sported distinctive, tall stacks. On most of the smaller boats, the imaginative puff-of-smoke-key made this troublesome but necessary accessory more attractive. Another distinguishing feature is the Carette rudder which while similar to the early Fleischmanns is one possible way to differentiate Carette from Marklin and Bing.

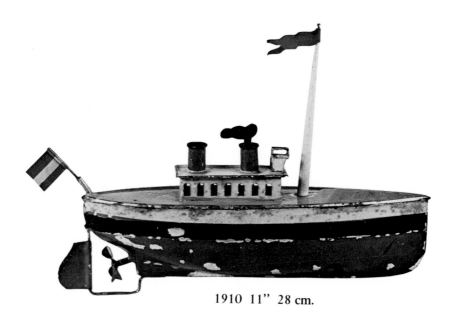

1910 11" 28 cm.

1900 7" 18 cm.

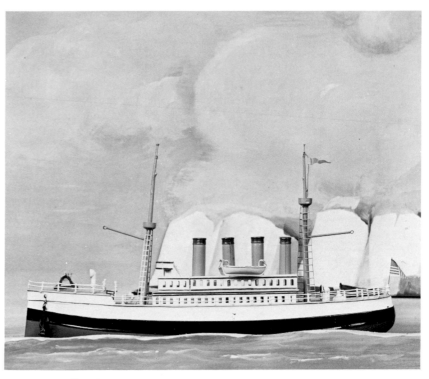

1900 21" 53 cm.

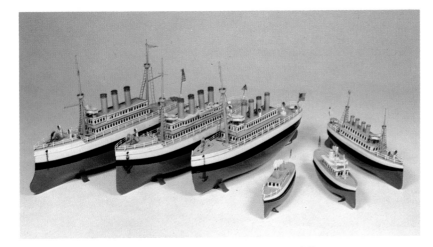

left to right: 1900 21" 53 cm.; 1910 19-1/2" 50 cm.;
1900 18" 46 cm.; 1914 7-1/4" 19 cm.; 1910 9" 23 cm.;
1900 12" 30 cm.

RESTORATIONS (below left and above right)

Dennis Fleck, who is head of *Forbes Magazine's* Balloon
Ascension Division, is also an expert restorer of toy boats. The
criteria for restoration is simple: the paint must be almost all
gone and the structural elements badly rusted, dented, or
missing. Paints are mixed to match other Carette liners of the
period and lost parts are often made by a local tinsmith. A
boat can lose appeal and value if restored badly but we felt
these boats would be enhanced with careful refurbishing.

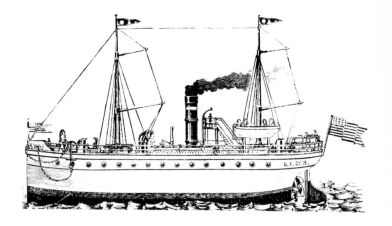

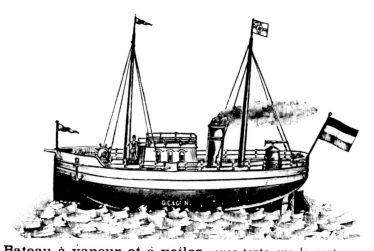

No. **713/8** **Bateau à vapeur et à voiles,** avec tente sur le pont, passerelle du commandant, barre, treuil pour les chaînes des ancres, avec gréement, longueur 40 cm

„ **713/9** le même, longueur 50 cm

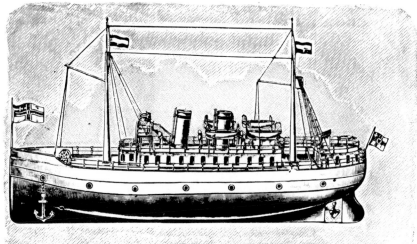

No.	**713/10**	longueur	60	cm, exécution et peintures très soignées	. . .
„	**713/10a**	„	60	„ extra soigné avec haquet	
„	**713/11**	„	65	„ „ „ „	
„	**713/12**	„	75	„ „ „ „	

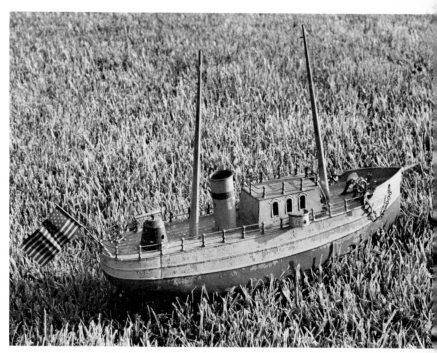

Carette 1905 15-3/4" 40 cm.

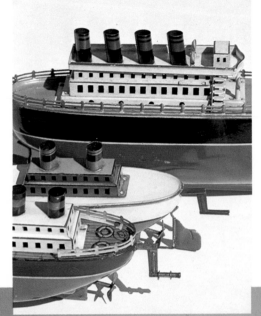

A distinguishing though not unique feature of many Arnold boats is the friction motor wound from the stern.

Arnold

Karl Arnold entered the Nuremberg toy world in 1906 with the production of a few tinplate toys, and in 1913 expanded production. But the war interrupted his business; all archives of these early years were destroyed. Between the First and Second World War this firm produced a large quantity of small toy ocean liners. After 1945 there appeared a few boats and some submarines, but around 1950 boat production ceased and only toy trains in N and O gauge were made.

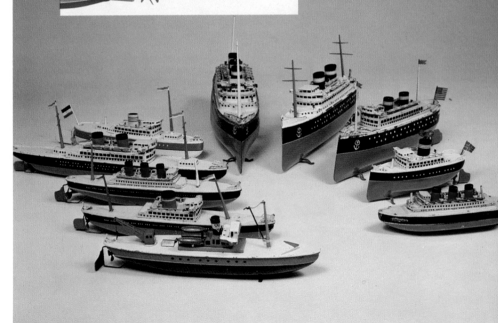

clockwise from left: 1950 12-1/2" 32 cm.; 1950 12-1/2" 32 cm.; 1950 12-1/2" 32 cm.; 1955 18" 46 cm.; 1955 14" 36 cm.; 1930 17" 43cm.; 1930 13-1/2" 34cm.; 1930 12-1/2" 32cm.; 1950 9" 23 cm.; 1930 9" 23 cm.

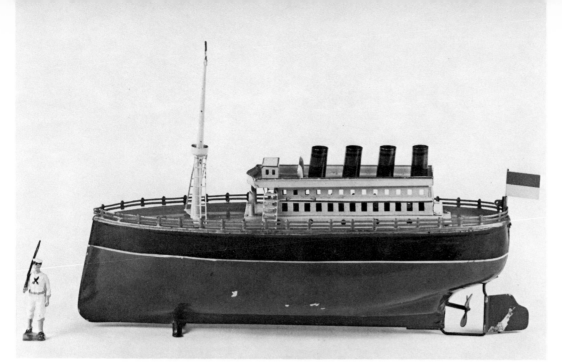

1920 21-1/2" 31cm.

1950 13-1/2" 34 cm.

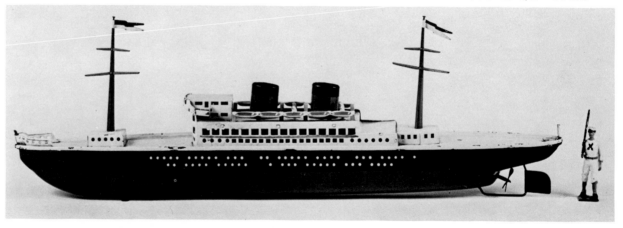

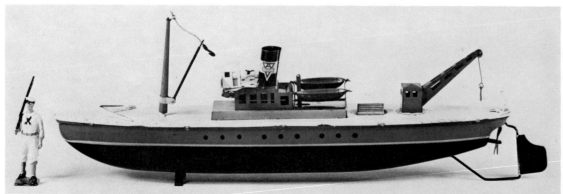

1955 18" 46 cm.

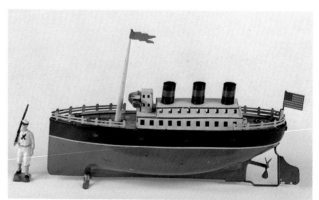

1914-1920 9" 23 cm.

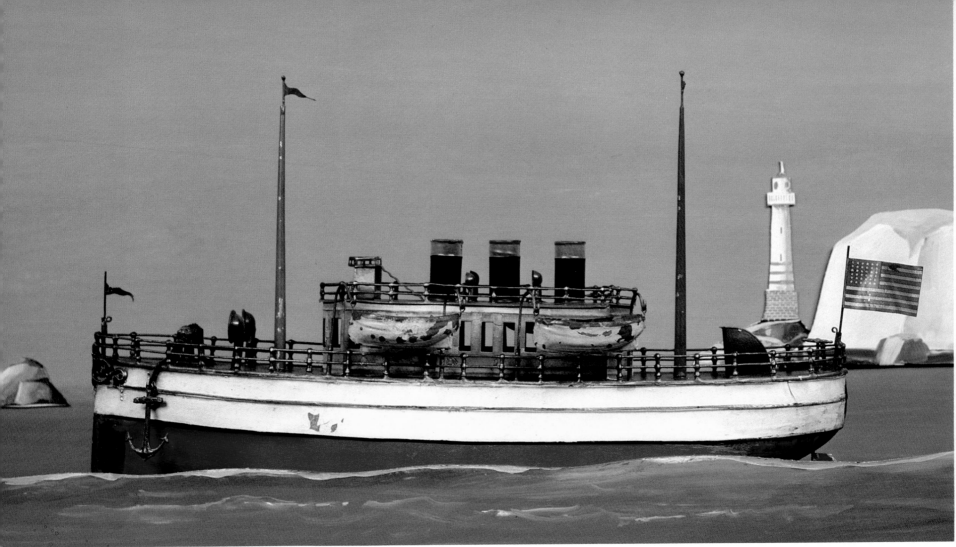

1905 21" 53 cm.

Falk

After working a while with Carette, Joseph Falk started his own toy company, specializing in steam toys and magic lanterns. When the firm of Jean Schoenner folded in 1913, Falk picked up his torch, i.e., his production plans and casting moulds, and started producing a beautiful line of ships. Never of great size nor really comparable in detail or finish to Bing and Marklin, Falk boats were distinct in a rather curious way.

Like the other boat manufacturers he used the large liners of the time as inspiration, but for some reason he chose to decorate his toys with funnels that appear to be disproportionately short, particularly by Carette-stack standards. Perhaps he foresaw the low art-deco stacks of the decade to come, but somehow the stacks on his boats simply appeared to be short. In 1925 Falk was taken over by Ernst Plank.

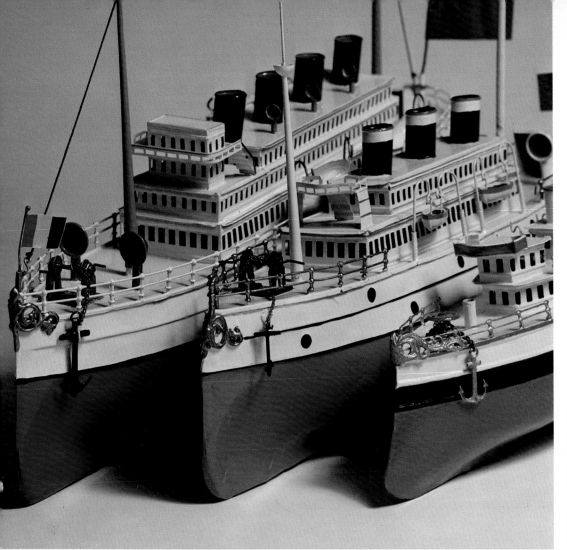

left to right:
1912 24" 61 cm.;
1905 20-1/2" 52cm.
16" 41 cm.

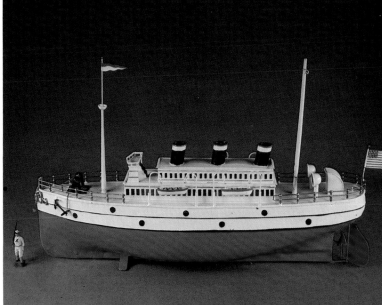

1905 20-1/2" 52 cm.

Compared to
Carette, Falk's stacks
are considerably
shorter.

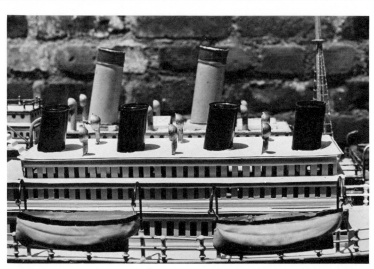

31

RIVERBOATS

Riverboats were popular for their evocative air of a leisurely Sunday trip on the Rhine, the Rhône, the Thames or the Hudson. Marklin's line of riverboats continued up to 1928 with this lovely boat, the *Loreley*, the largest they offered. Here her condition is superb, right down to the cloth canopies.

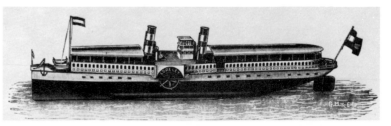

Loreley 1923 30" 76 cm.

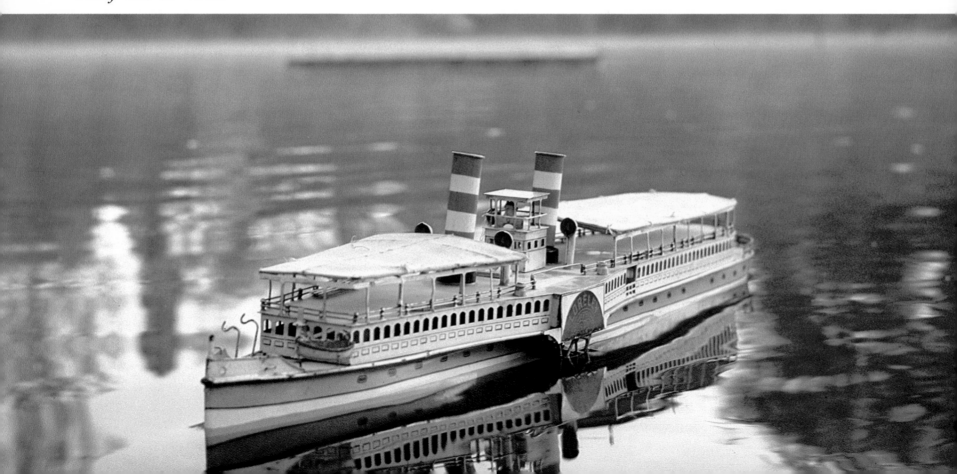

This wonderful extraordinary boat looks like a Marklin sister
ship: it is painted in the same distinct manner, but while
detailed accoutrements are similar it does not appear in any
catalogues of the time. (And like many Marklins, it sits very low
in the water!)

Louise 13" 33 cm.

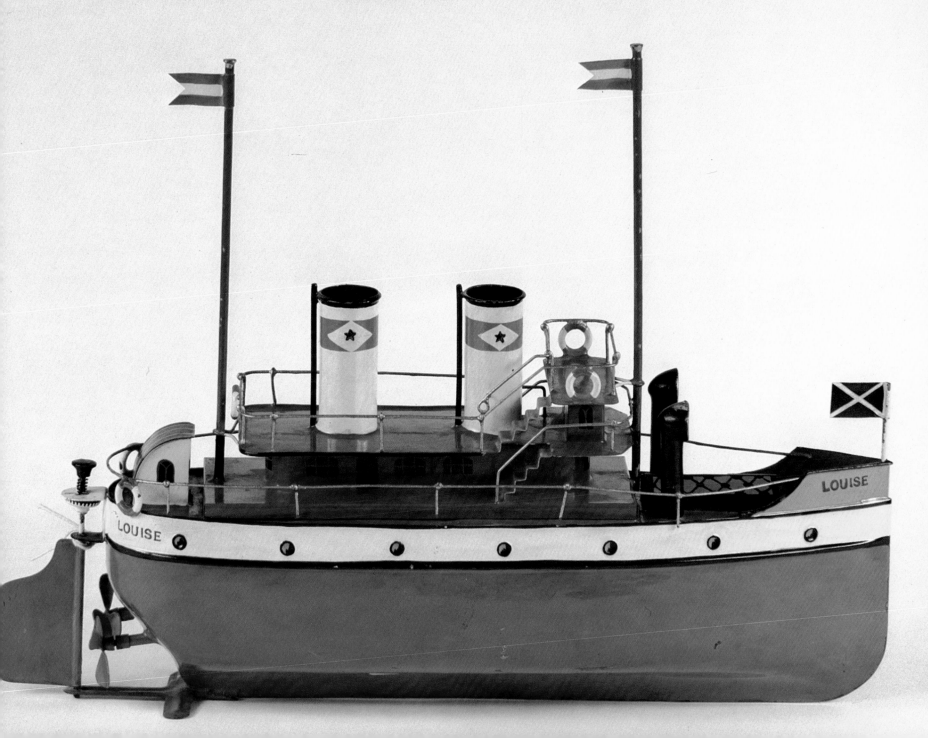

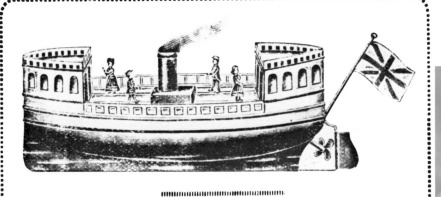

Bateaux mécaniques de plaisance avec voya-
geurs mobiles

Longueur 21 c m **18** Frs

This delightful boat features four flat figures that "walk" around the deck as the boat chugs ahead. The catalogue page comes from F. Meurice and Company, a French toy importing firm that unfortunately makes no reference to the boat's manufacturer.

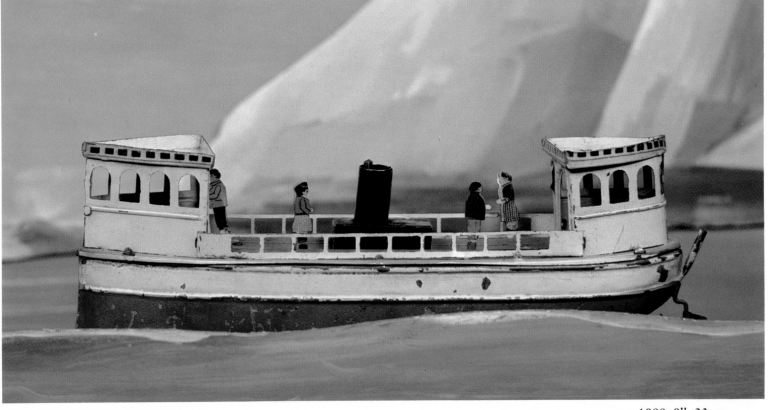

1900 9" 23 cm.

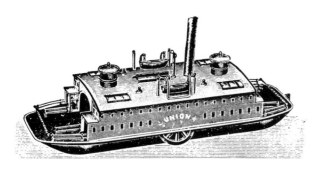

505/10/3 *Ferry Boat*, exact model with guaranteed *clockwork* and moved by 2 side wheels.

Made in 3 sizes.

From the 1917 US Bing catalogue

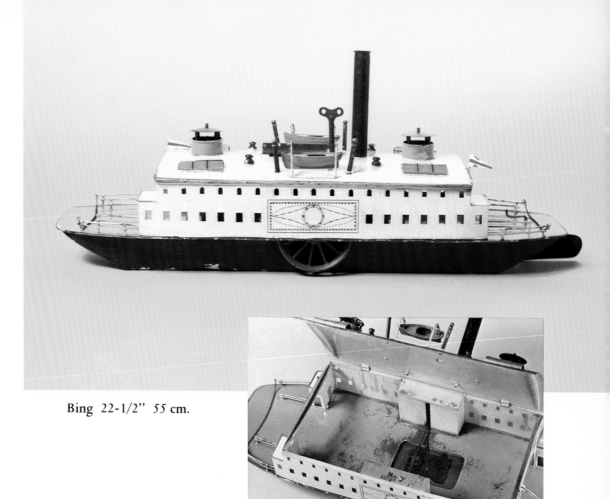

Bing 22-1/2" 55 cm.

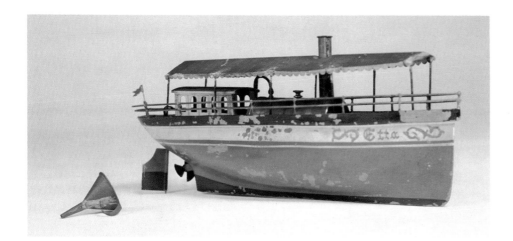

Schoenner *Etta* 1900 15-1/2" 39 cm. Also written on the stern is her intended port, New York.

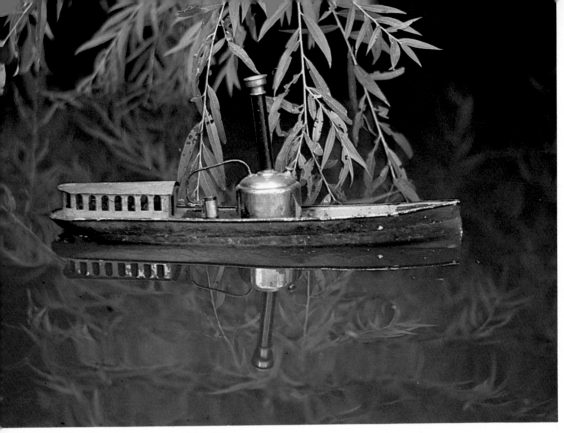

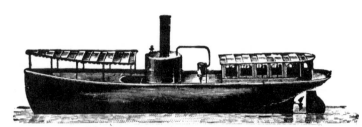

N· **805.** — **Vapeur à hélice**, avec salon et pont couvert, chaudière en laiton, avec cylindre oscillant et soupape de sûreté.

Longueur : 36 c/m.

Prix **Fr.** **4.50**

Schoenner 1898 14-1/2'' 37 cm.

Schoenner 1891 11-1/2'' 29 cm.

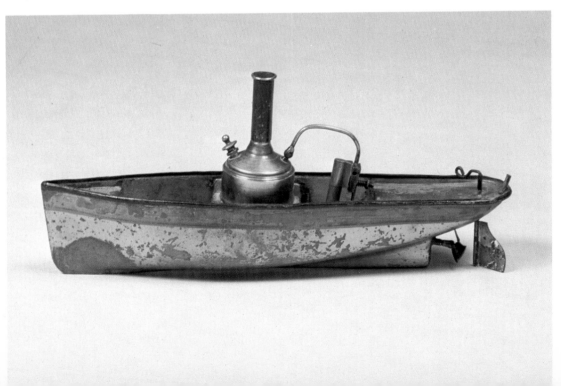

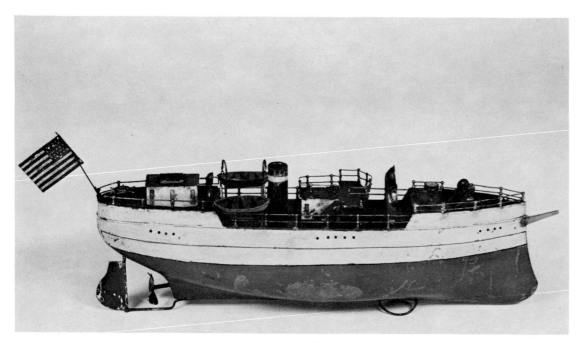

Carette 1902 19" 48 cm.

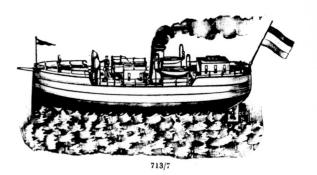

713/7

Bateau à hélice
soigneusement verni, avec
ressort solide.

Paquebot.

No. **713/7** longueur 40 cm,
exécution riche

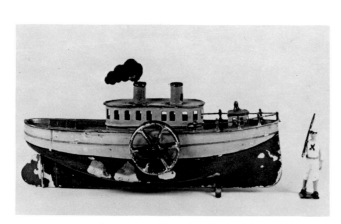

Carette 1900 9" 23 cm.

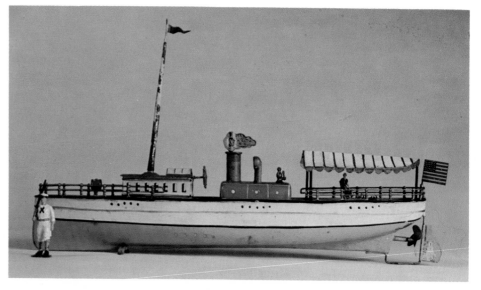

Carette 16" 41 cm.

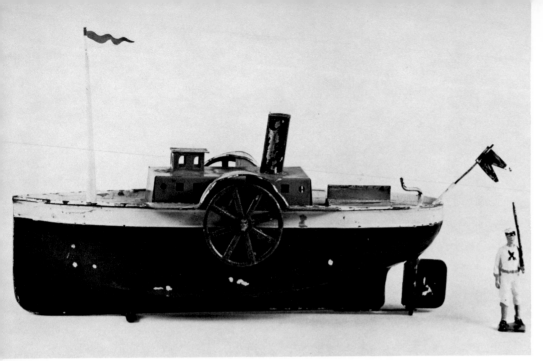

Bing 1910 10-1/2" 27 cm.

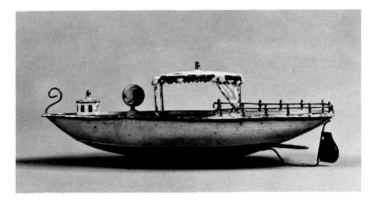

J. Falk 10" 25 cm.

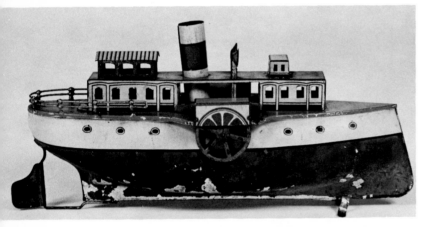

Arnold 1920 10" 25 cm.

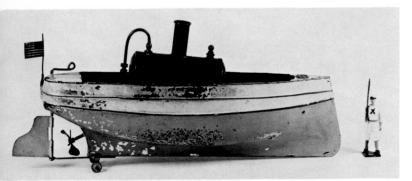

Plank 1905 11-1/2" 29 cm.

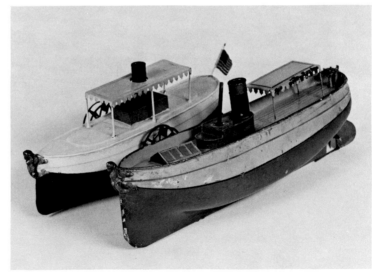

11" 28 cm. 12-1/2" 32 cm.

According to Arno Weltens in his book,
Mechanical Tin Toys in Color, these two boats
are from the Nuremberg company of
Uebelacker.

Often a Victorian/Edwardian sense of elegance was found in boats such as these from Maltête & Parent, a French company noted for their elaborate figureheads, painted designs at the waterline and filigreed wheelhousings. The firm founded under Napoleon III won a medal at the Paris Exposition of 1878.

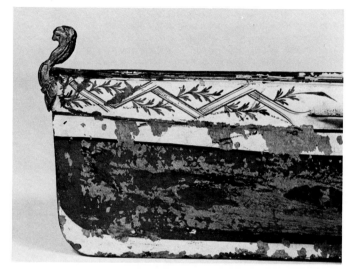

Maltête & Parent 1900 22" 56 cm.

Maltête & Parent 1880 15" 38 cm.

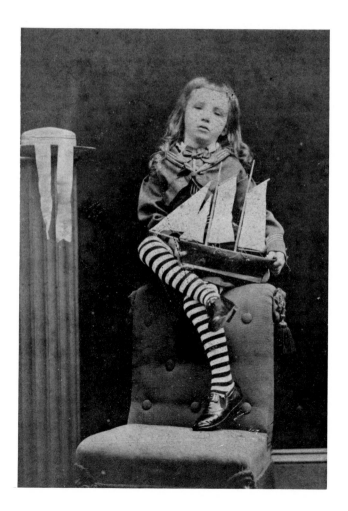

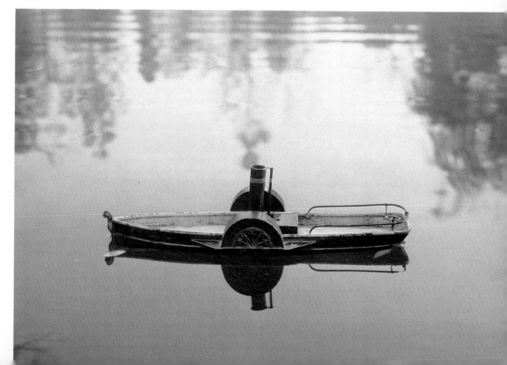

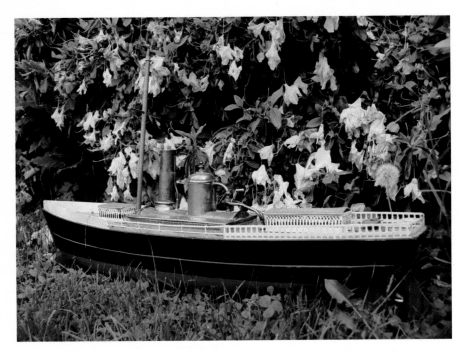

H. Barre 1900 29" 74 cm.

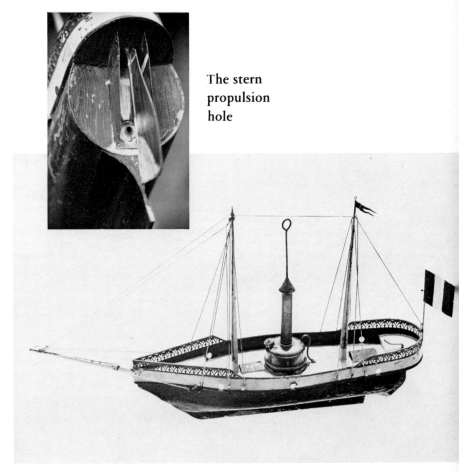

The stern propulsion hole

H. Barre 1868 24" 61 cm.

These two French steamboats are very rare and come from the firm of H. Barre founded in 1850. The ship in the upper left appeared around 1900 and is made in a way similar to boats from Radiguet; the hull though, is not of zinc but of base metal and it runs on steam. The boat, right, is much older, dating from 1868. This Barre boat, however, does not have a steam-driven propeller and instead is powered by a jet of compressed hot air forced out the back.

A Noah's Ark 1910 11" 28 cm.

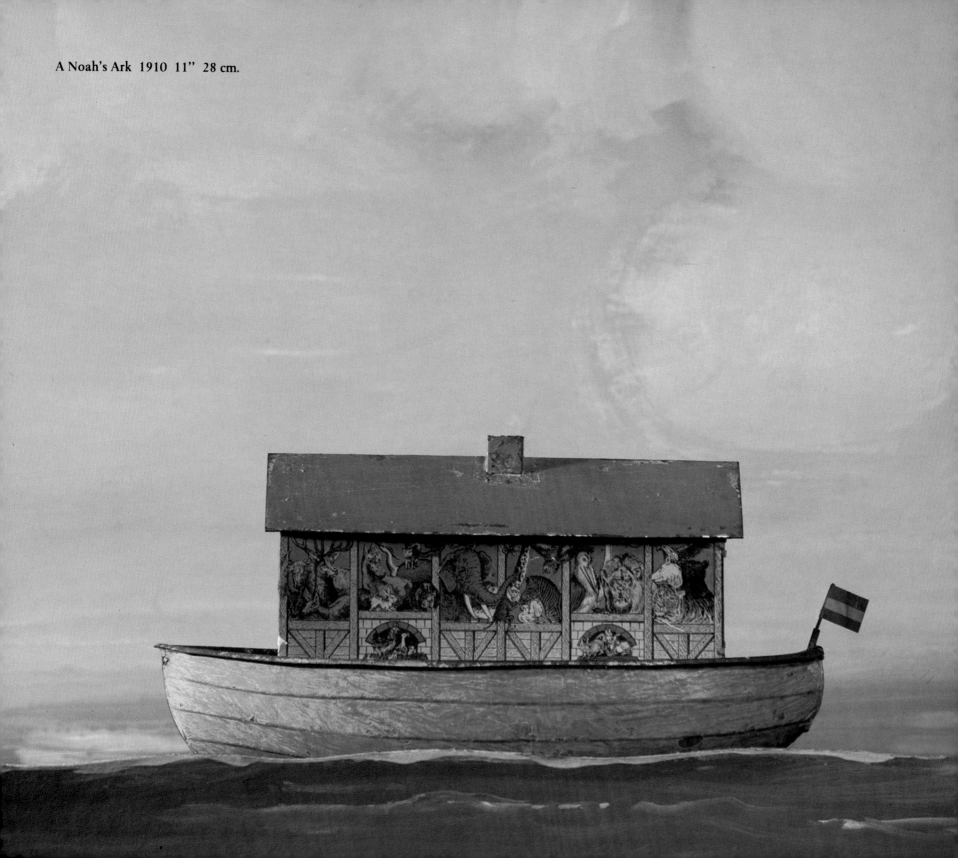

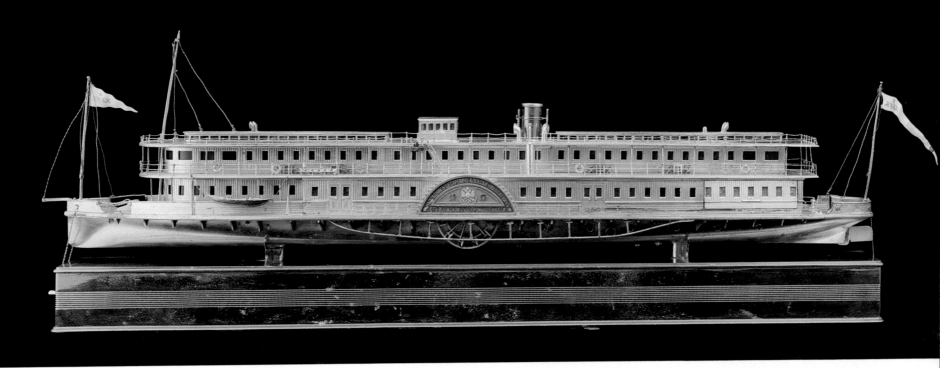

Though not strictly a toy this *Silver Presentation Paddle Steamer* is special. Made by Fabergé for the Volga Shipbuilders who presented it to Czar Nicholas' only son Alexis in 1913, the boat contains a music box that plays *God Save the Czar* and *Sailing Down the Volga.* The young Czarevitch loved the sea and spent most of his short life under the watchful eye of a sturdy Russian sailor because of his hemophilia.

In both these Fabergé frames the Czarevitch sports a hatband with the name of the Imperial yacht, *Standard.* This picture is actually a postcard that was sent by his mother Empress Alexandra to her lady-in-waiting as a New Year's greeting for 1909.

Here he's shown on the deck of the *Standard.*

Ives

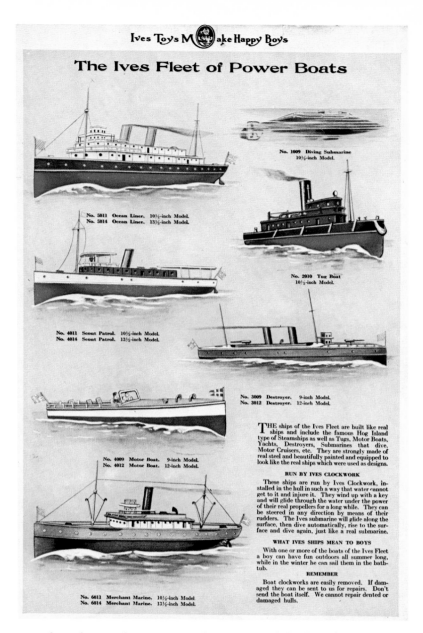

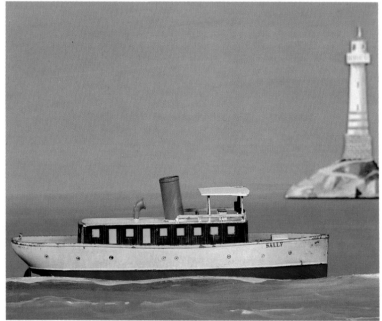

Sally 1923 10-1/2" 27 cm.

The color catalogue page is from 1923, while the others on this and p. 46 are from 1918 when Ives was trying to interest their young clientele in the U.S. Merchant Marine.

Ships of the Ives Navy
IVES DESTROYER - - *THE PROTECTOR OF THE FLEET*

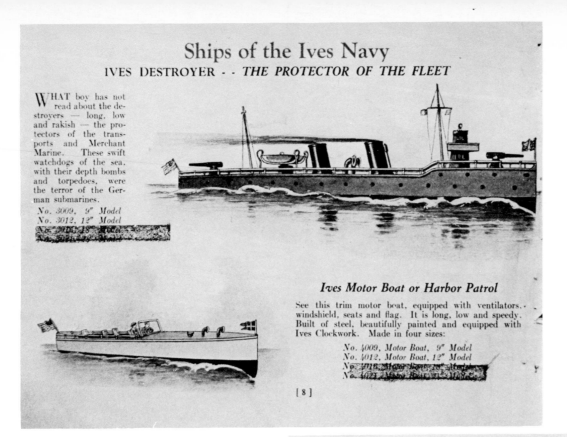

WHAT boy has not read about the destroyers — long, low and rakish — the protectors of the transports and Merchant Marine. These swift watchdogs of the sea, with their depth bombs and torpedoes, were the terror of the German submarines.

No. 3009, 9" Model
No. 3012, 12" Model
No. 3018, 18" Model

Ives Motor Boat or Harbor Patrol

See this trim motor boat, equipped with ventilators, windshield, seats and flag. It is long, low and speedy. Built of steel, beautifully painted and equipped with Ives Clockwork. Made in four sizes:

No. 4009, Motor Boat, 9" Model
No. 4012, Motor Boat, 12" Model
No. 4018, Motor Boat, 18" Model
No. 4021, Motor Boat, 21" Model

[8]

Ives Boats and Ives Trains are on sale in all good stores handling toys.

If your dealer cannot supply you, write us.

THE IVES MANUFACTURING CORPORATION
Bridgeport, Connecticut, U. S. A.

46

(P1036—IM—Noorder)

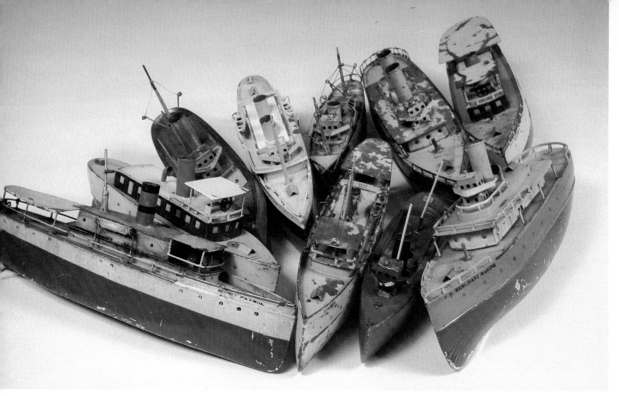

Ives boats were not painted with a primer or undercoating, and the paint now flakes off very easily. These boats show the progress made in their design, from the relatively thin, less detailed ship, to the larger, wider models from the later two phases of manufacture. Known for their fine trains, Ives tried to tap the growing nautical market but the venture was not a financial success.

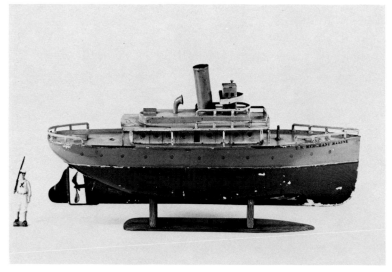

US Merchant Marine 1923 13-1/2" 34 cm.

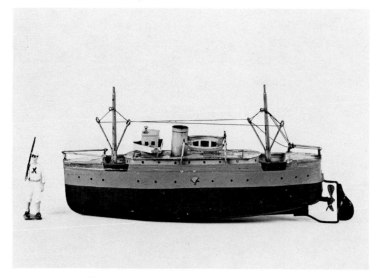

1918 9" 23 cm.

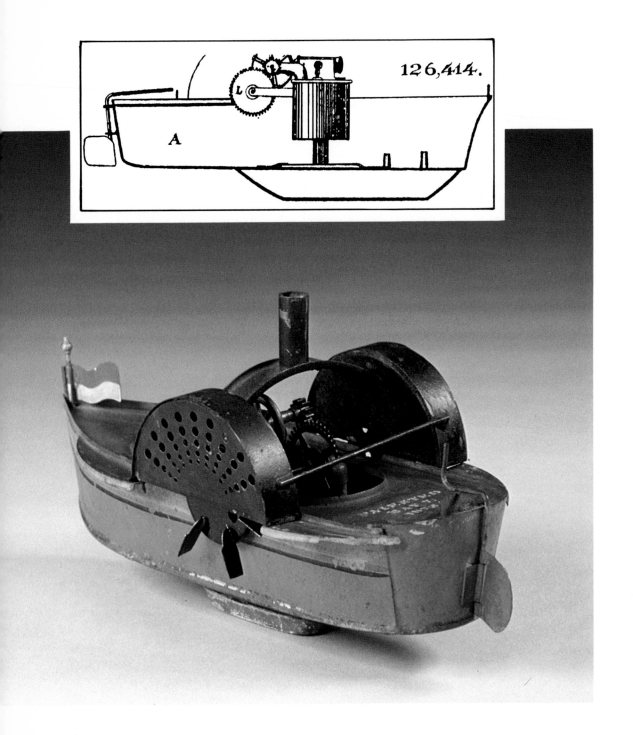

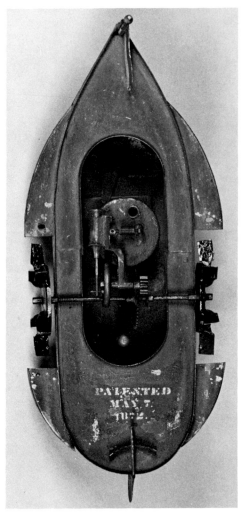

Bramwell, Smith 10-1/2'' 27 cm. Patented
May 7, 1872. Note the drawing from the US
Patent Office Gazette.

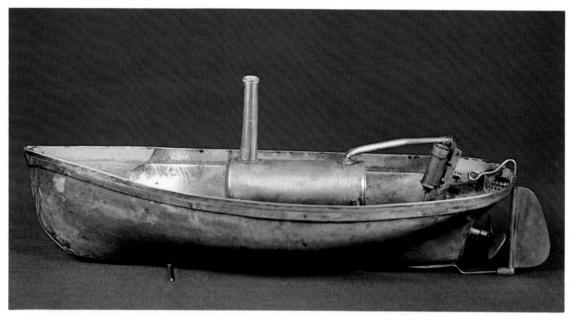

Buckman 1890 12-1/2" 32cm.

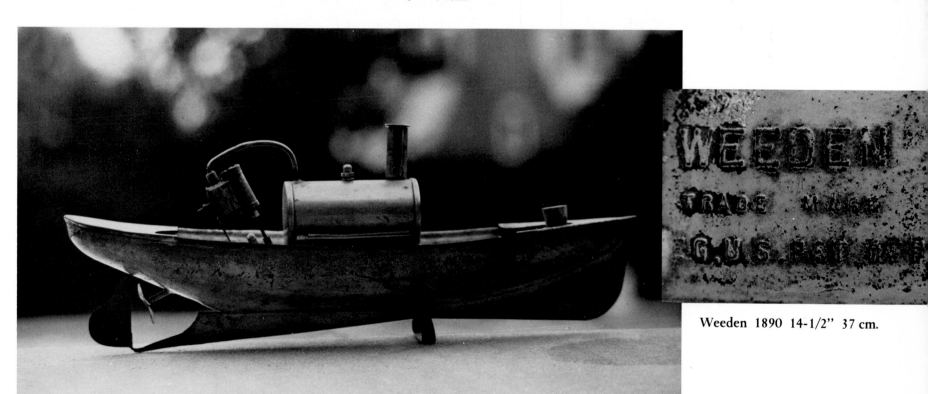

Weeden 1890 14-1/2" 37 cm.

49

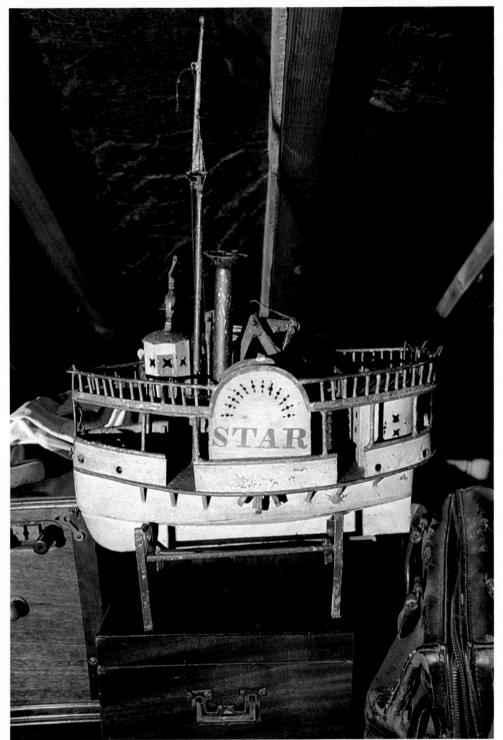

The origin of the *Star* is unknown and was the recent subject of great scholarly speculation: is it a production toy or simply a singular model? No matter. Made in the mid-Nineteenth Century when the great sidewheelers plied the Mississippi its naive style and delightful foreshortened perspective reflect the prevalent American style of toys of the period.

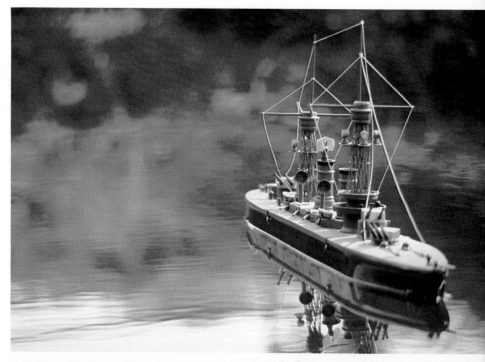

WARSHIPS

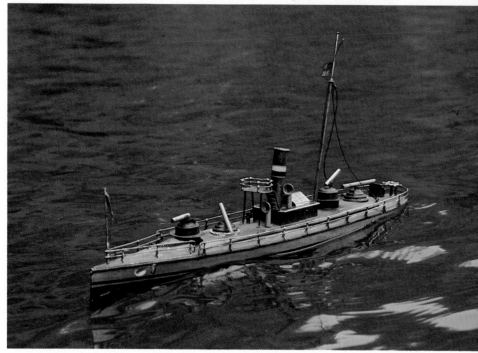

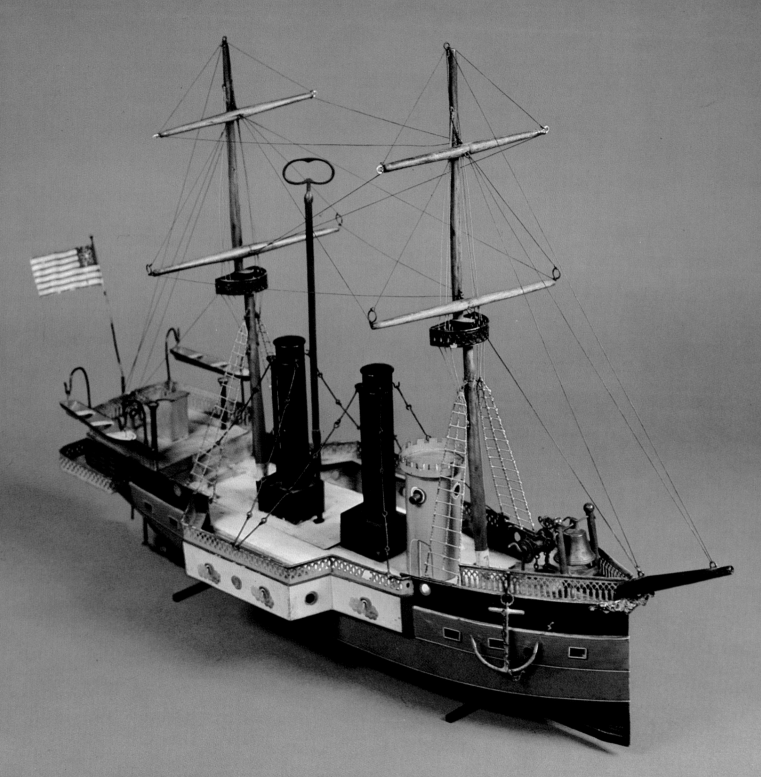

1895 30" 76 cm.

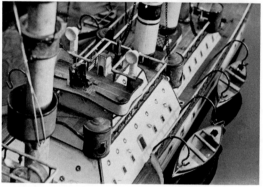

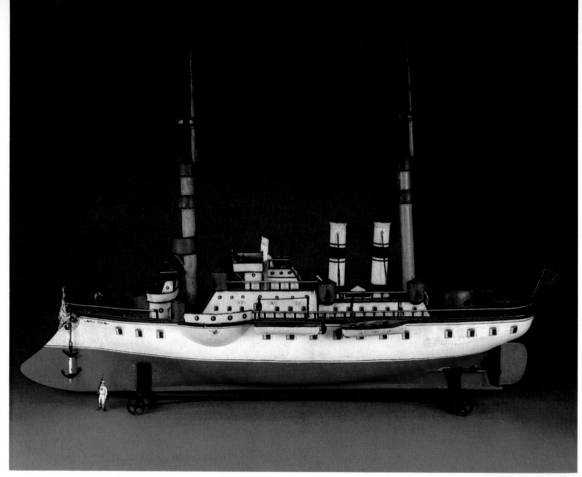

New York 1900 41" 104 cm.

Marklin

FIRST SERIES 1859-1906

In the beginning, the First Series of Marklin's navy was actually comprised of a few gunboats, the emphasis up until then having been the production of river boats and yachts. The exquisite warship *opposite* could easily have been produced as a pleasure boat. The turret turns and has one small working cannon. The guns intended for the other holes are missing, but otherwise all else is there. Note the working double winch and the rope ladders made of cast lead.

But then in 1898 the German Army in certain newspapers demanded that there be more war toys manufactured.

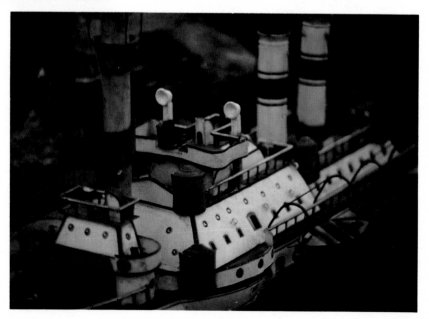

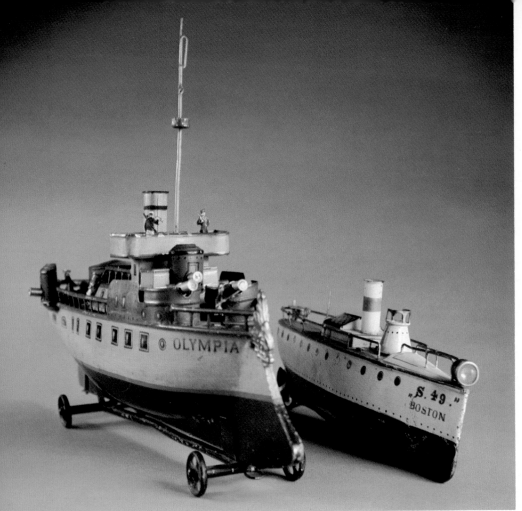

Marklin responded to the demand and produced boats that are still considered along with their peace-time counterparts among the most beautiful toys ever made: these First Series warships were extremely well built, detailed, and perfectly painted by hand. They were mainly cruisers and large gunboats with a few torpedo boats and small single cannon boats in the lower price range. The larger ships up to 41" 104 cm. were driven by clockwork, carried masts with a number of look-out posts or crow's nests, generally had two stacks, four lifeboats and came equipped with a complete crew of lead sailors and officers. Bristling with up to 15 rounded gun turrets they also came with a wheel carriage and a tremendous price tag, up to 300 gold francs.

Olympia 17" 43 cm.; *Boston* 13" 33 cm.

Indiana 1902 13" 33 cm. A Britains Ltd. detachment of Edwardian-era sailors are seen readying the deck for an inspection.

The *Indiana* is typical of the small Marklin boats of the First Series. It is armed with two small cannons that could actually be loaded with a small charge of gunpowder which was set off by a fuse.

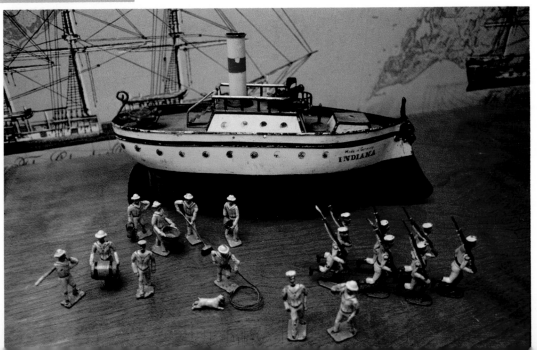

SECOND SERIES 1906-1918

Marklin's Second Series was a magnificent squadron of
battleships, cruisers and torpedo boats with submarines
appearing a little later (see p. 75). The torpedo boats were
often driven by hot air shot out the stern (see p. 57). The
larger anti-torpedo boats, up to 29-1/2'' 75 cm. long, were the
first of the series to use steam engines, had swiveling guns,
lifeboats and a crew. The cruisers had clockwork motors and
up to ten guns, spotlights that a battery could light up,
working semaphore flags (Marconi was still experimenting),
two working cranes, all of which could be driven for a slightly
higher price by a steam engine.

It was the great battleships of this series, however, that
neared perfection. While the slightly smaller versions came
with steam, electricity, or clockwork, the grandest (measured
42'' 106 cm.) came with only electric or clockwork
power. But what battleships these were, with two propellers
driven by a very solid reinforced brass boiler, cannons with
gunpowder charges, working cranes for the lifeboats, working
spotlights and semaphores. Like Bing's Third Series of ocean
liners, these Marklin beauties paid attention to graceful lines
and were detailed only up to a certain functional point, not to
where the detailing overwhelmed the ship's toy-like aspects as
happened in the next series.

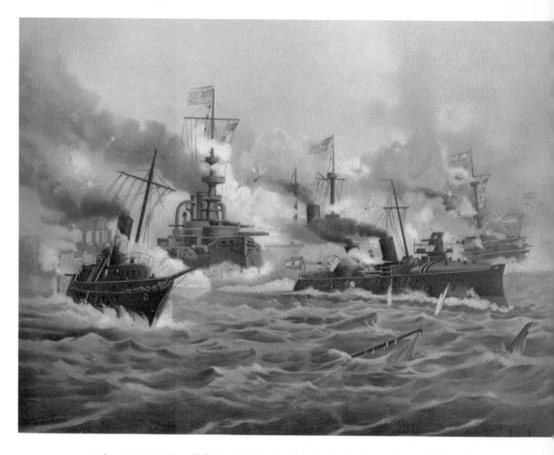

**The US's "Splendid Little War" with Spain inflamed world headlines
with the terrific naval exploits of Admiral Dewey.**

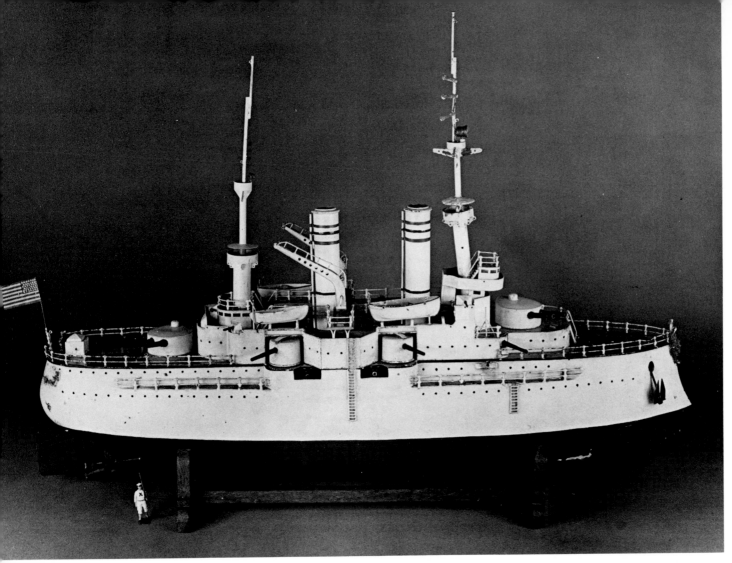

Pennsylvania 1910 40" 102 cm.

This fine example from Marklin's Second Series has dropped some of the charming exaggerations found on the *New York,* p. 53. Nevertheless, it's a grand and powerful looking battlewagon that still retains the feel of a toy.

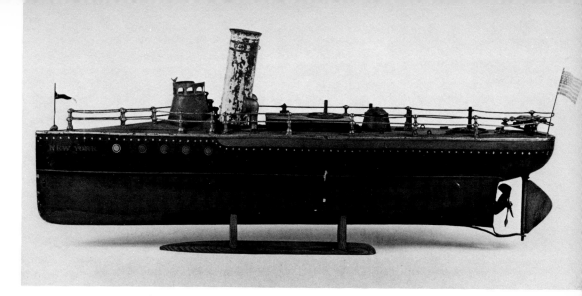

New York 1910 20" 51 cm. From the Second Series, the torpedo boat *New York* lacks its original funnel.

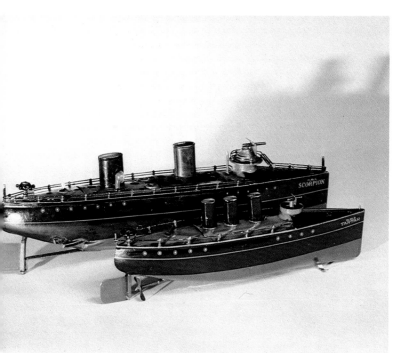

HMS Scorpion 16-1/2" 42 cm.; *HMS Tartar* 12" 30 cm.

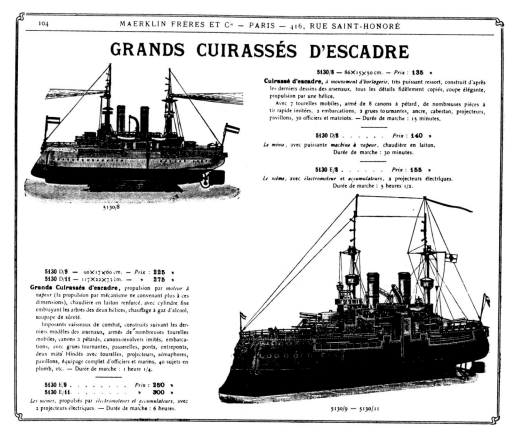

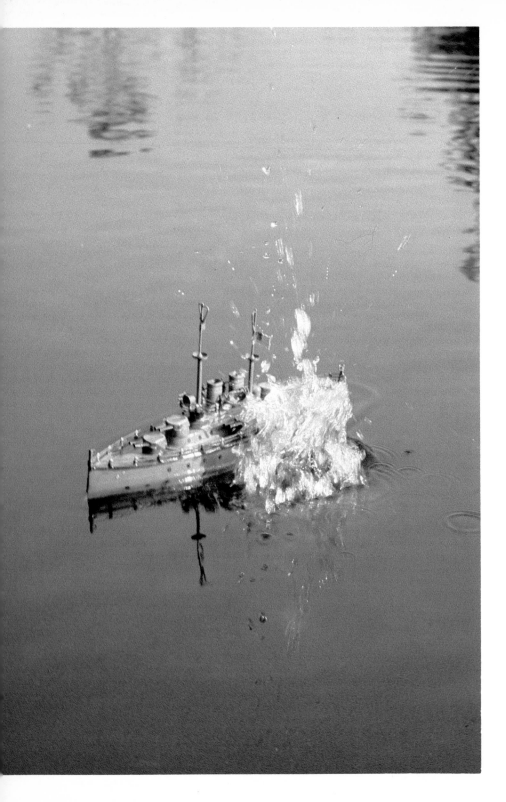

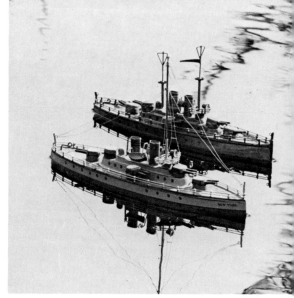

These two exquisite Marklin sister ships from the Third Series are both in perfect condition, doubling their fun.

New York both 1914 14" 36 cm.

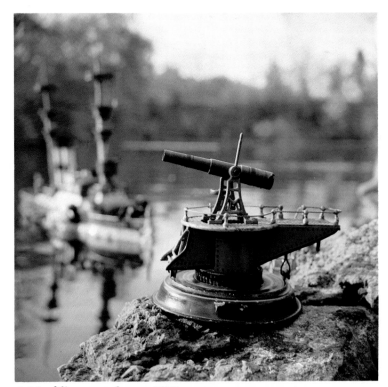

A Marklin coastal gun, 1902.

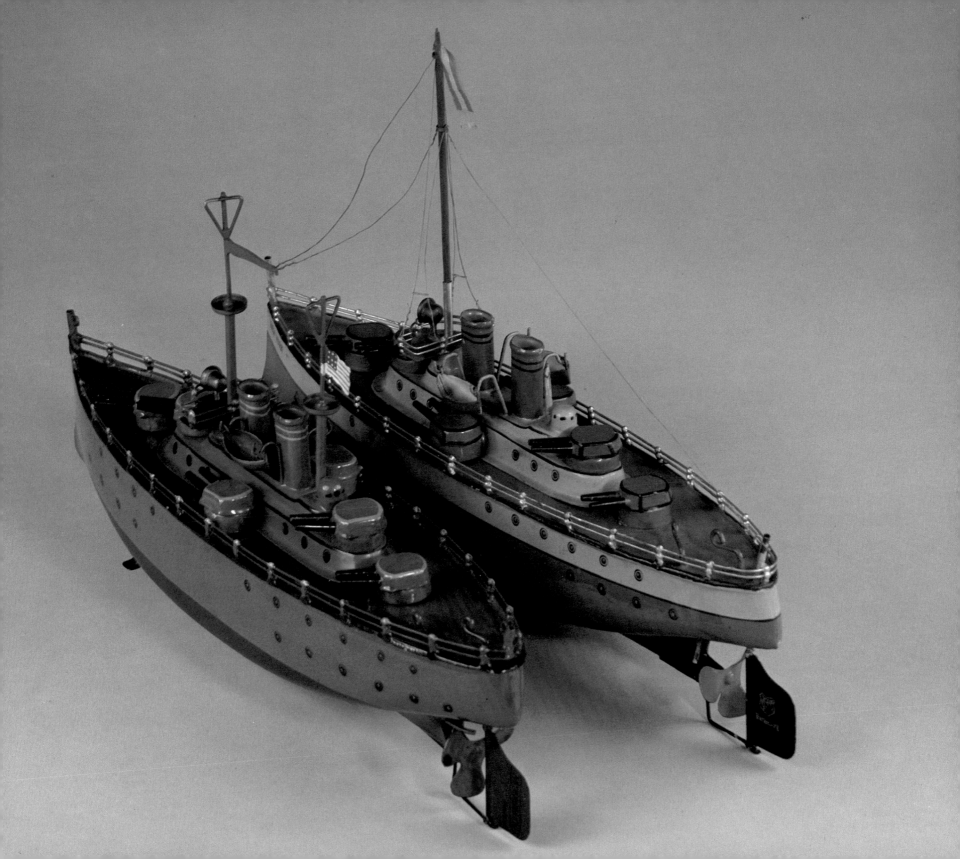

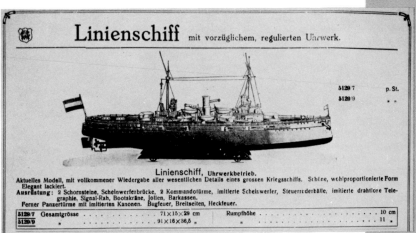

THIRD SERIES 1918-1936

This was the great period of the "Linienschiff" or "ships
of the line" and tremendous submarine production. In
1923 appeared two very fine examples of the
"Linienschiff" (28" 71 cm. and 37" 94 cm.) that were
modeled on the lines of the great battleships of the time.
This is the last series of beautiful boats from Marklin
and one could say that around 1933 the last great
battleship (opposite) was made. It measured 36" 91 cm.,
sported three propellers, a removable superstructure, 6
revolving turrets, armored crow's nests on both masts,
walkways, electric spotlights, removable launches and
working cranes. But while this large ship reflects a
certain loss of "playability" the two smaller sister ships,
pp. 58-9, capture the warship's fierceness in miniature
with no loss of wonder and enjoyment. Once this period
was over, Marklin no longer made boats except some
small ones and just before the Second War there are
only submarines to be found in the catalogues.

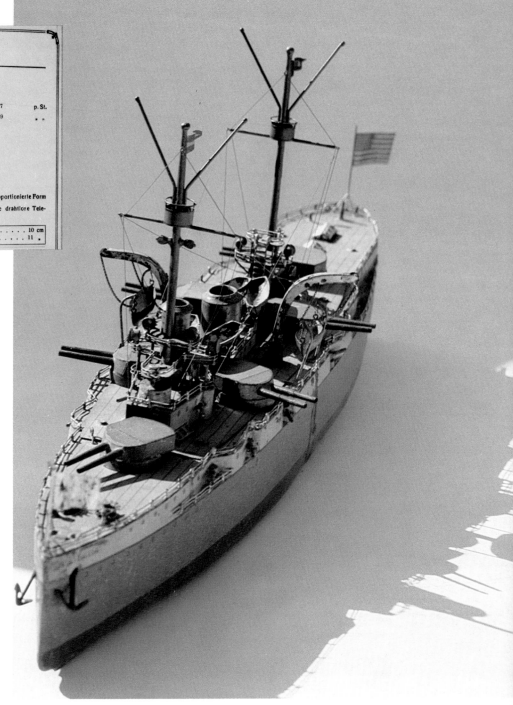

Missouri 1933 36" 91 cm.

Bing

The first Bing warships appeared in catalogues around 1898, and are as rare and valuable as the First Series from Marklin. They have similar detailing and overall quality of workmanship, yet they sank less often than their Marklin counterparts because they were lighter and did not sit as low in the water.

The Bing warships ran quite well and were less costly. Unfortunately, however, before the First World War their quality began to fall off, most noticeably in the detailing; the clockwork mechanism, though, remained superb.

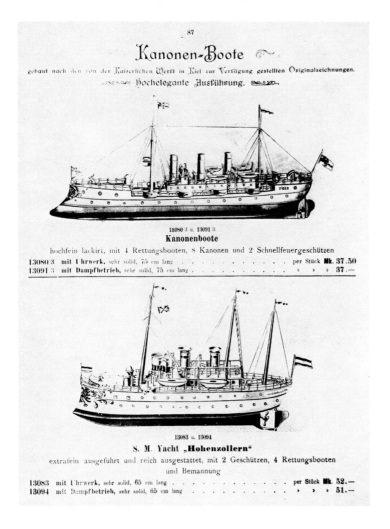

King Edward VII 1902 29" 74 cm. Restored by A.W. Grant Nelson to near original condition. ☞

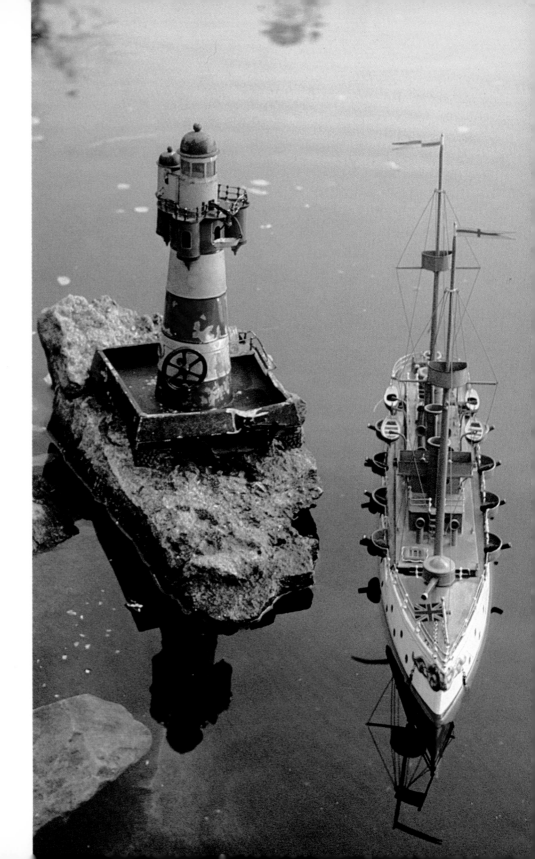

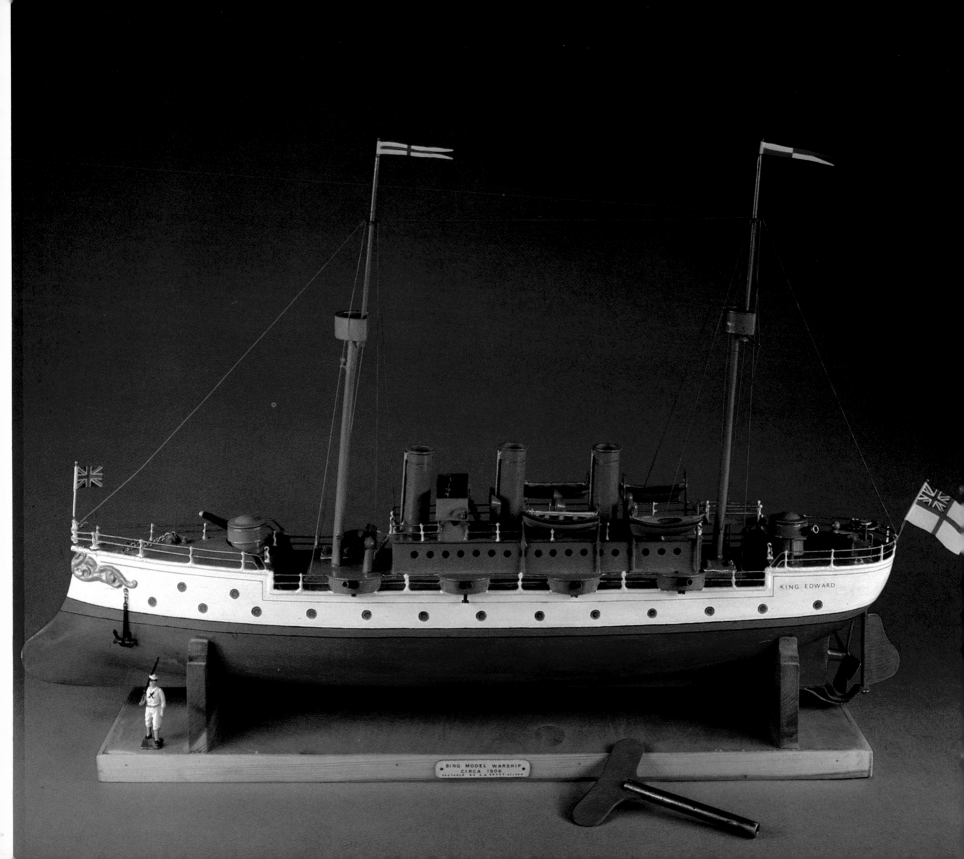

KING EDWARD

BING MODEL WARSHIP
CIRCA 1906

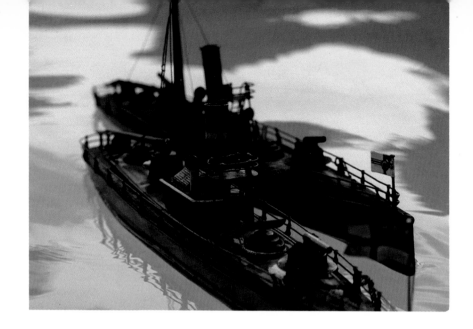

Two models of Bing's popular torpedo boats from around 1900. Notice the attention to detail not found in some of the later models.

Three generations of Bing warships.
Foreground: 1900 23" 58 cm.; center left to right: 1915 16" 41 cm.;
1904 15" 38 cm.; 1914 13" 33 cm.; both 1912 16" 41 cm.; 1915 21" 53 cm.;
Decatur 21" 53 cm.; 1915 8-1/2" 22 cm.
rear: 1910 12" 30 cm.; 1910 19" 48 cm.; 1910 26" 66 cm.

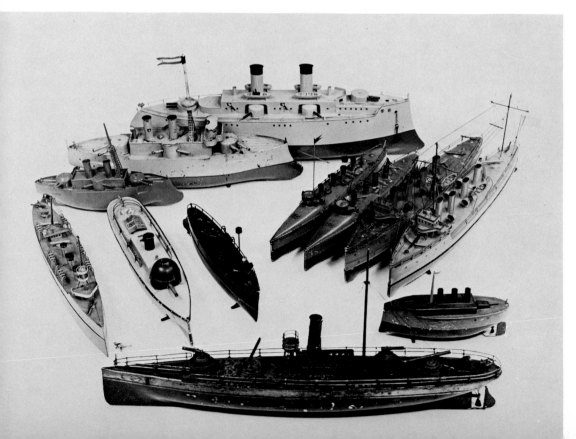

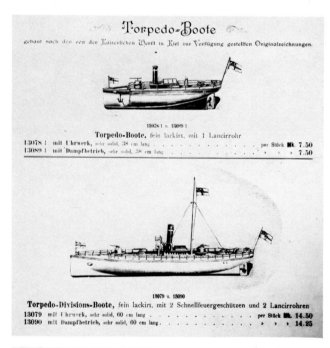

Torpedo-Boote
gebaut nach den von der Kaiserlichen Werft in Kiel zur Verfügung gestellten Originalzeichnungen.

13078 1 u. 13089 1
Torpedo-Boote, fein lackirt, mit 1 Lancirrohr
13078 1 mit Uhrwerk, sehr solid, 38 cm lang per Stück Mk. 7.50
13089 1 mit Dampfbetrieb, sehr solid, 38 cm lang » » 7.50

13079 u. 13090
Torpedo-Divisions-Boote, fein lackirt, mit 2 Schnellfeuergeschützen und 2 Lancirrohren
13079 mit Uhrwerk, sehr solid, 60 cm lang per Stück Mk. 14.50
13090 mit Dampfbetrieb, sehr solid, 60 cm lang » » 14.25

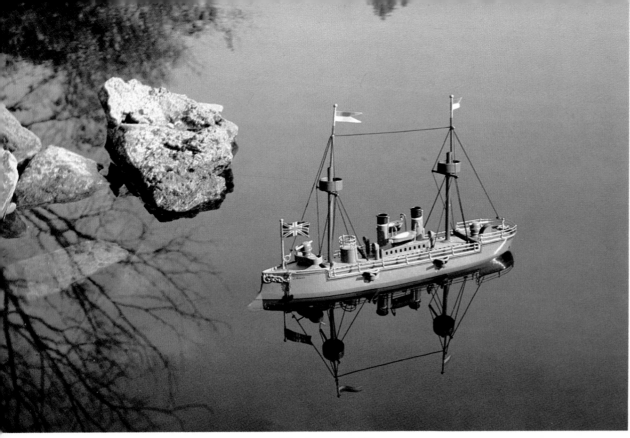

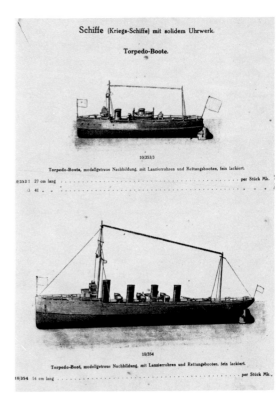

L'Antonio 1910 21" 53 cm. Restored by Jacques Milet.

A Bing catalogue page, 1912.

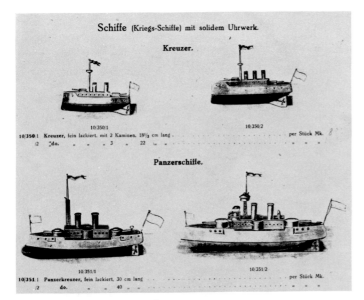

From a 1915 catalogue

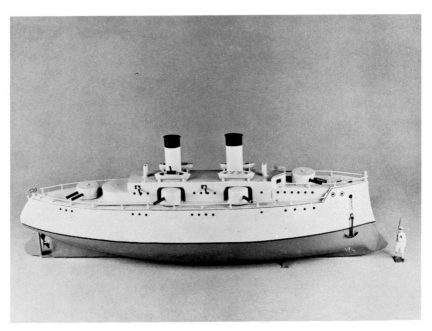

1910 26" 66 cm.

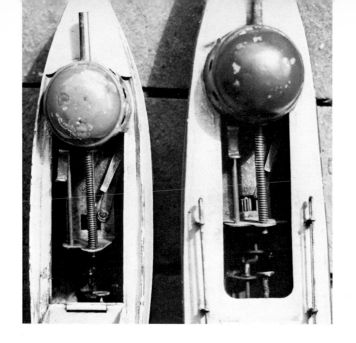

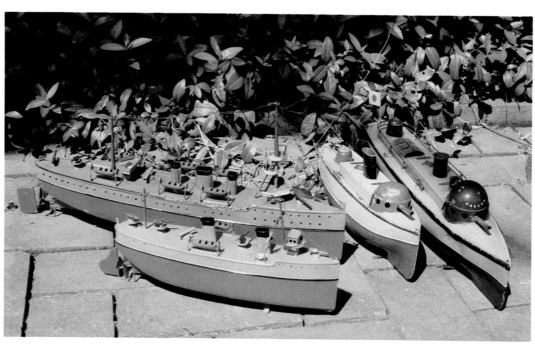

left: Named after a Japanese cruiser, the *Kasuga* has a timing mechanism that fires the gun and turns the rudder 90°.
below: 1915 10-3/4" 27 cm.; 1915 16-1/4" 41 cm.; 1904 10-1/2" 27 cm.; *Kasuga* 1904 14-1/2" 37 cm.

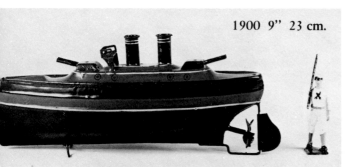

1900 9" 23 cm.

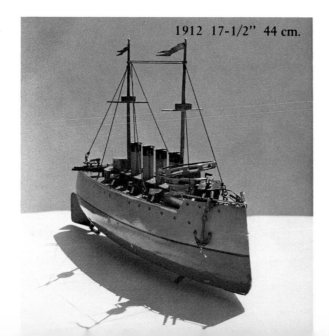

1912 17-1/2" 44 cm.

Decatur 1912 21" 53 cm.

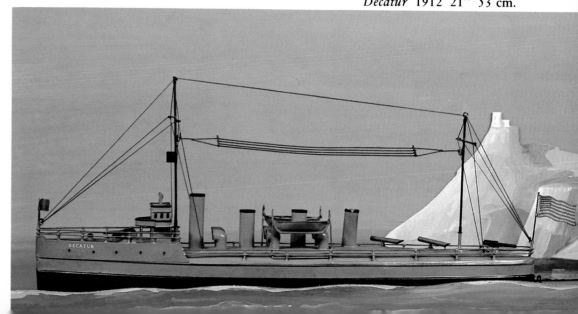

Fleischmann

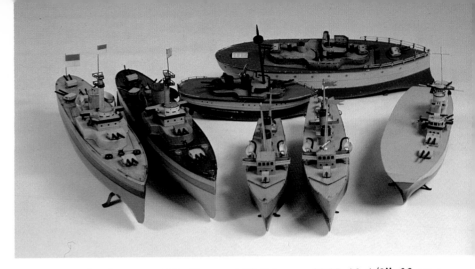

front row: both 1955 20" 51 cm.; 14" 36 cm.; 1955 12-1/2" 32 cm.; 1955 16" 41 cm.; rear: 1925 11" 28 cm.; 17" 43 cm. Both older ships were still available from a 1936 Fleischmann catalogue.

The firm of Fleischmann was the last among the ship builders to produce warships but managed to produce them up through 1955 and even then in great quantity. The aircraft carrier 14" 35 cm., restored, is a very rare example of the warship that General Billy Mitchell helped spawn during his dramatization of the might of air power. The style of Fleischmann gun turrets did not change over the years.

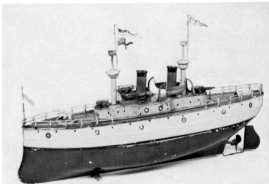

1936 17" 43 cm.

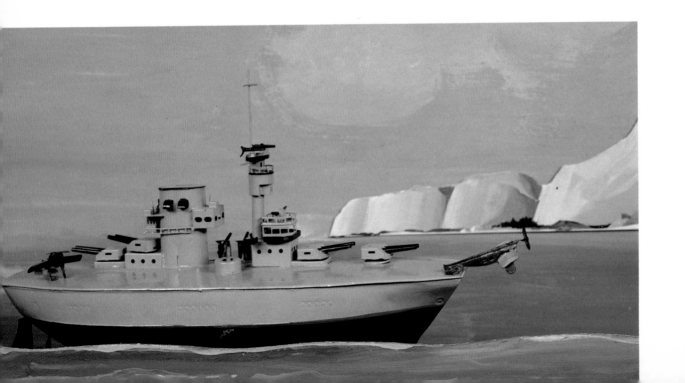

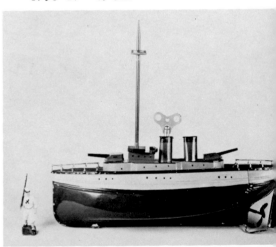

1936 10-1/2" 27 cm.

Carette

A characteristic though not unique aspect of the small Carette gunboats is the puffing smokestack key, as seen on the ocean liners (p. 25). Another identifying clue is the distinct style of deck gun. A playful addition (below, top right) was a small compass on the stern.

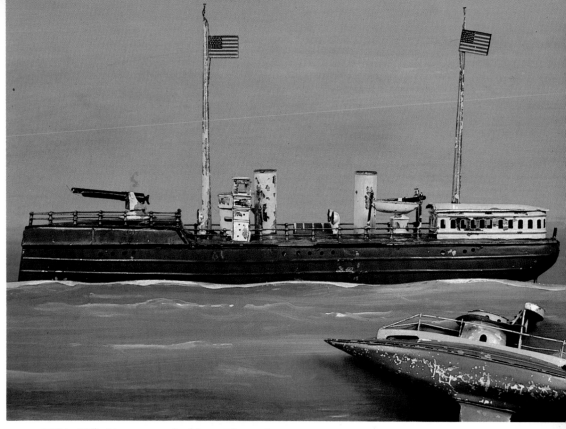

1904 20" 51 cm. attacked by a Bing sub

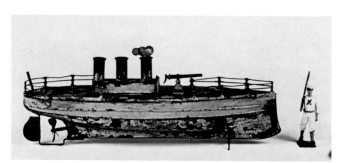

1904 10" 25 cm.

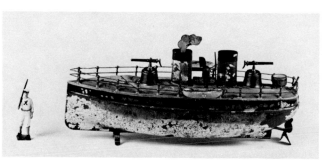

1904 11-1/2" 29 cm.

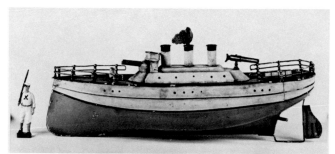

1910 10" 25 cm.

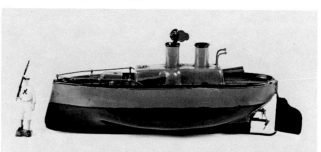

1904 12" 30 cm.

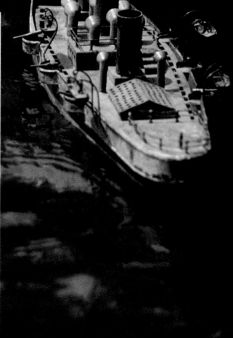

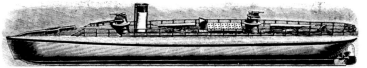

Torpilleurs
à mouvement d'horlogerie

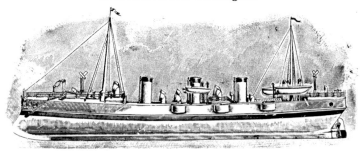

Nᵒˢ **825/1-2.** — **Torpilleurs** à mouvement d'horlogerie, exécution très soignée. Sur le pont sont montés, 2 tubes lance-torpilles, 2 canons (modèle à tir rapide), 2 ancres démontables. Le tout verni soigneusement.

Numéros.	825/1	825 2"
Longueur	54 c/m.	62 c/m.
Prix. **Fr.**	**14.50**	**21.50**

Nota. — Les ressorts sont très forts et la force d'impulsion d'une longue durée.

Avisos de guerre à vapeur
ou à mouvement d'horlogerie

Nᵒˢ **827/1 à 3.** — Exécution très soignée, vernis finement. Avec chaloupes, mâts, ventilateurs, cheminées, ancres, canons démontables, etc. Machine avec chaudière en laiton et cylindre en laiton.

Numéros :	827/1*	827/2	827/3
Longueur :	50 c/m	60 c/m	75c/m
Prix : Fr.	**18.50**	**33** »	**52** »

La vapeur s'échappe par une des cheminées.

NOTA. — Les ressorts d'horlogerie sont très forts, et la force d'impulsion est d'une longue durée.
* *Le Nᵒ 827/1 ne se fait qu'à mouvement d'horlogerie.*

From Jean Schoenner, this is a sleek and beautifully proportioned ship that lacks only its masts.

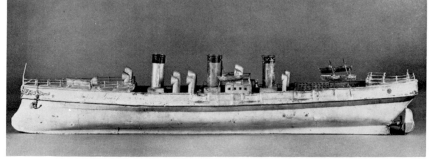

Schoenner *Aviso Greif* 1900 28-1/2" 72 cm.

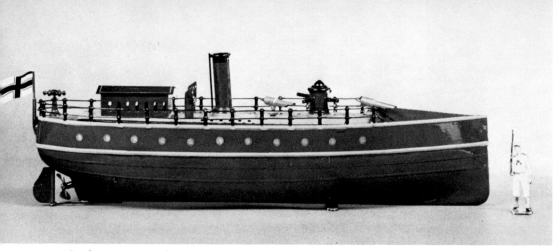

Plank 1930 15-1/2" 39 cm. This live steam gunboat has been completely restored.

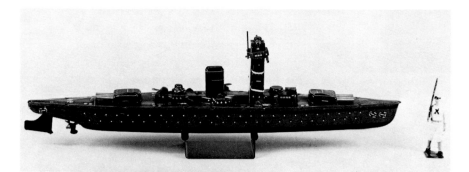

K351 1939 13-1/2" 34 cm.

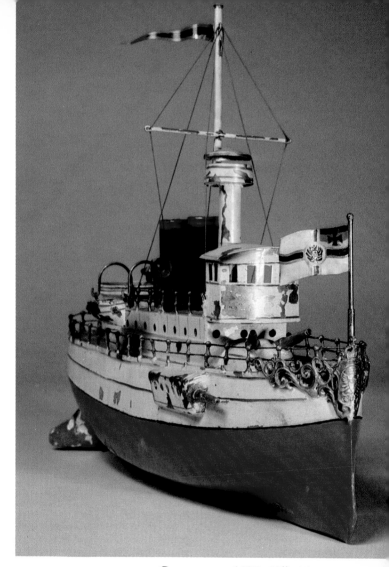

Germany c. 1900 18" 46 cm.

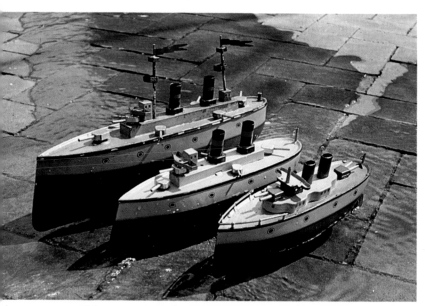

Arnold 1920: 11-1/2" 29 cm.; 10" 25 cm.; 8-1/2" 22 cm.

Plank 1925 16" 41 cm.

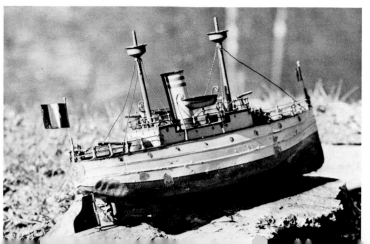

69

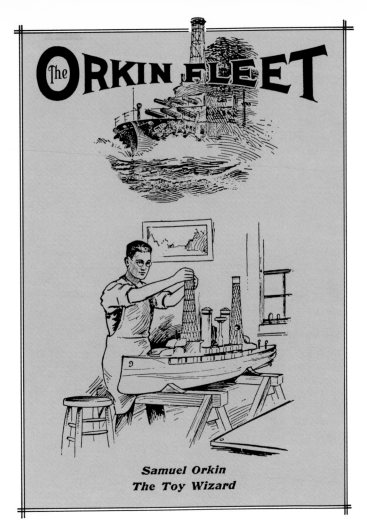

Samuel Orkin
The Toy Wizard

Orkin

As seen in these catalogue pages, Sam Orkin created a line of American warships unlike any produced in Europe. From the success of a large working model he built during the First World War and displayed around the country he decided to make boats that reflected the values he felt young boys needed in their toys. Orkins were modeled after existing U.S. Navy ships and were built to last. Available at a relatively low price, these boats while somewhat ungainly do have a certain Yankee do-it-yourself charm.

Later purchased by the president of the Waterman Pen Company in search of a good toy boat for his son, the firm produced a line of pleasure boats called Orkincraft. Nathan Polk bought the firm in 1940 and waited until the war ended before resuming production; he soon found, however, that prices of toys made of plastic were too hard to compete with.

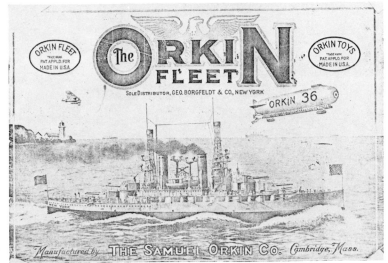

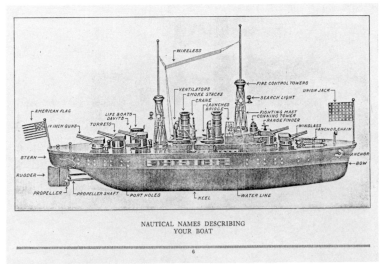

NAUTICAL NAMES DESCRIBING
YOUR BOAT

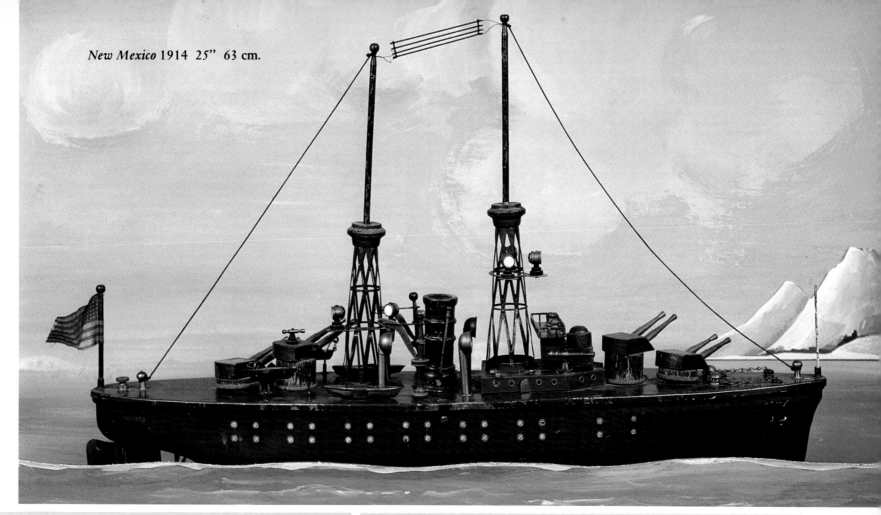

New Mexico 1914 25" 63 cm.

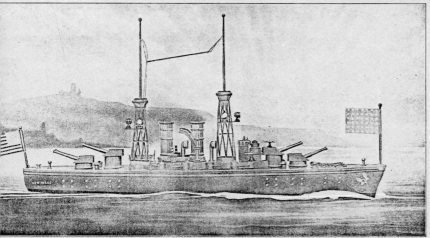

U. S. S. NEW MEXICO, *Superdreadnaught*

Length 605 ft.; beam 99 ft.; displacement 32,000 tons; horse-power 29,000; speed 21 knots; guns: twelve 14-inch, twenty-two 5-inch; four 21-inch torpedo tubes; crew, 1056 men.

Specifications of ORKIN model of New Mexico. Length 25 inches; beam 4½ inches; draft 2¼ inches displacement.

NOTE: "New Mexico," "Mississippi" and "Idaho" are sister ships.

The above picture is from an actual photograph of the Orkin model superdreadnaught.

11

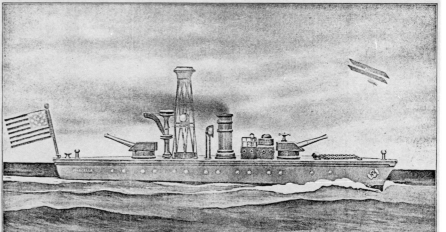

U. S. S. MARCELLA, *Cruiser*

The average cruiser is about 500 ft. in length, 70 ft. in breadth, has a displacement of about 15,000 tons, horse-power about 28,000 and a speed around 22 knots. The guns consist of the rapid fire kind and anti-aircraft; has also submerged torpedo tubes. The Marcella is not the name of a particular boat, but is characteristic of cruisers in general, the name having been selected by the manufacturer. The above is the Orkin model of this ship.

Specifications of ORKIN model of Cruiser. Length 18½ inches; beam 3¼ inches; draft 1⅜ inches.

13

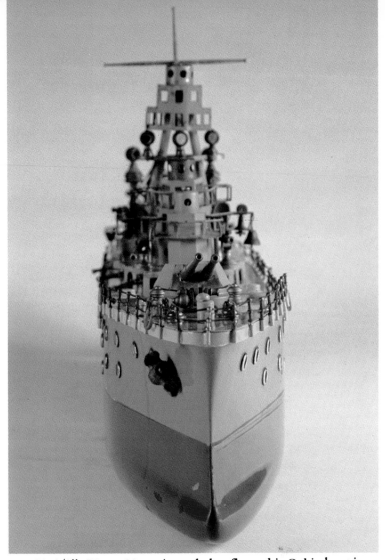

28-1/2" 72 cm. Never intended to float, this Orkin boat is probably a prototype: note the brass fittings and the two types of paint design on the hull.

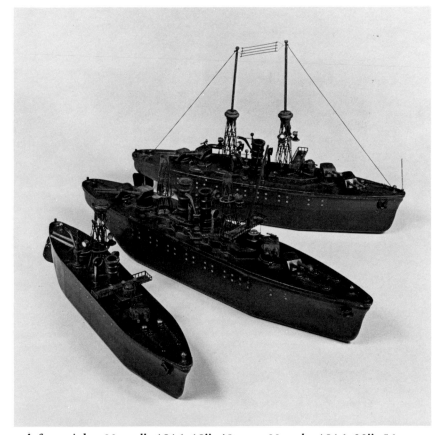

left to right: *Marcella* 1916 19" 48 cm.; *Nevada* 1916 22" 56 cm.; *New Mexico* 1916 25" 63 cm.

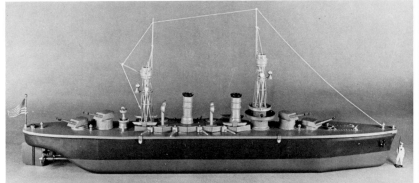

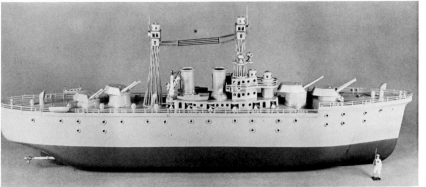

1920 36" 91 cm. Both of these ships have been restored. 1929 34" 86 cm.

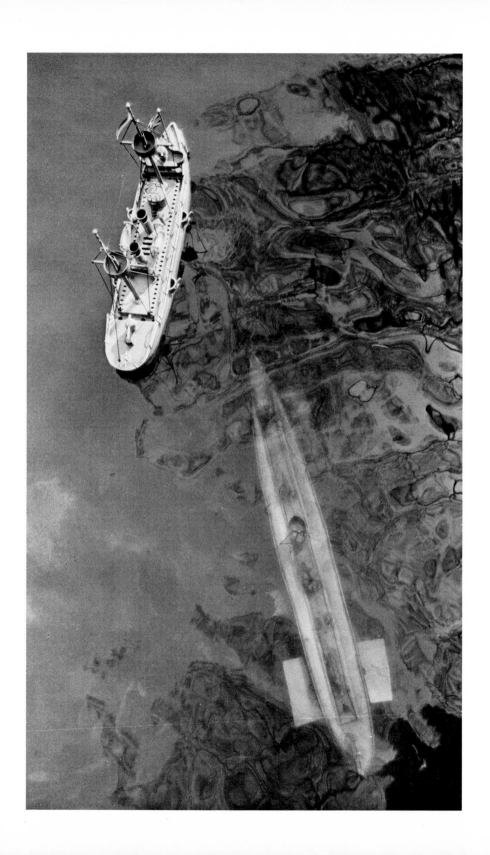

SUBMARINES

The popularity of toy submarines was due in large part to a curious incident.

As told in the *Berliner Tageblatt* of December 1913, "The Kaiser entered a large toy store on the Leipzigerstrasse in Berlin. He wanted to be shown the toys that were for sale.

"After he had seen the locomotives and the battleships he asked, 'and the submarines?'

There were no submarines to be found. "You do not have any submarines, sir? You must. You must, I tell you! It is necessary that young Germans understand well that the German maritime strength is invincible, that the future lays not only on but under the water.' He then asked for a pencil and quickly drew on a piece of paper a design for a toy submarine and left very angry, ordering that this model be produced by the factories of Bing and Marklin.

"Thus the educational purpose of toys is more or less unquestionable." (From *Les Jouets de France*, by Leo Claretie.)

Marklin

As usual, the most prestigious, the most sought after were the U-Boats made by Marklin. Their clockwork motors had a thrilling automatic cycle: The submarine dived and returned to the surface time after time until the clockwork ran out at which point, if submerged, the sub rose again realistically to the surface. The sizes varied from 8-1/2" 22 cm. at 39 francs up to 31" 79 cm. for 479 francs. A high-priced toy indeed. The bigger ones came complete with a periscope and a lifeboat.

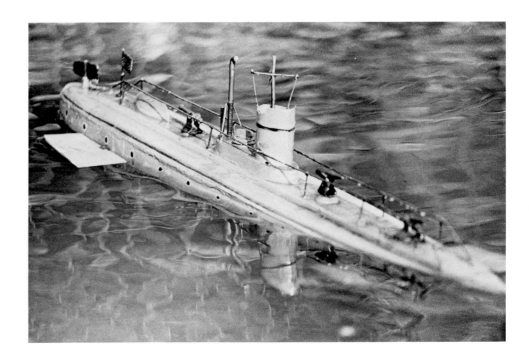

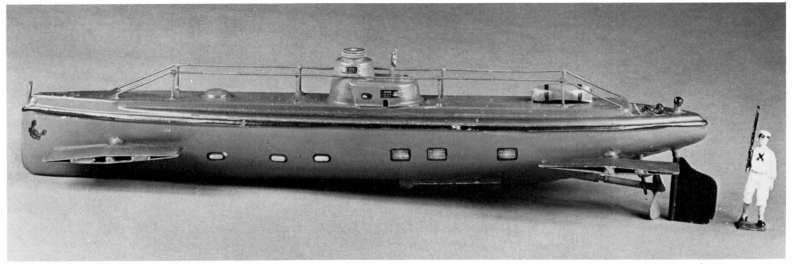

1920 21-1/2" 55 cm.

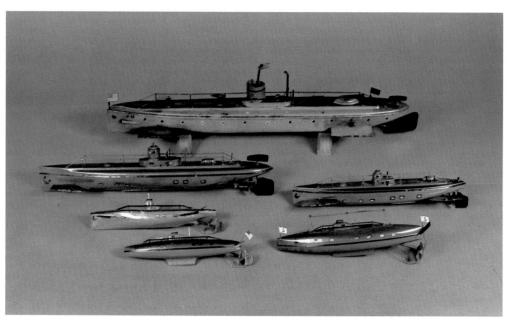

Marklin subs, clockwise from rear: 1920 31" 79 cm.;
1925 16" 41 cm.; 12-1/2" 32 cm.; 11" 28 cm.;
1914 11-1/2" 29 cm.; 1920 21-1/2" 55 cm.

The largest submarine came from the son of the
caretaker-chauffeur, Mr. Lafenetre, who found it in
the lake of the Henry Clay Frick family's summer
estate.

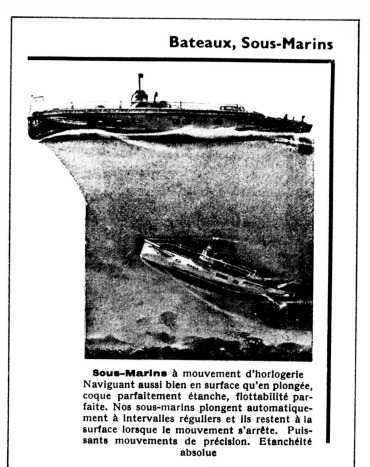

Bateaux, Sous-Marins

Sous-Marins à mouvement d'horlogerie
Naviguant aussi bien en surface qu'en plongée,
coque parfaitement étanche, flottabilité par-
faite. Nos sous-marins plongent automatique-
ment à intervalles réguliers et ils restent à la
surface lorsque le mouvement s'arrête. Puis-
sants mouvements de précision. Etanchéité
absolue

A catalogue page that appeared just before
the Second World War.

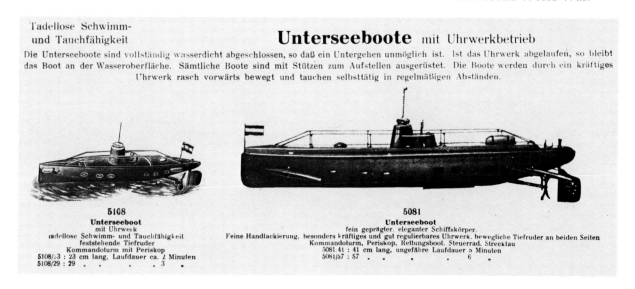

Tadellose Schwimm-
und Tauchfähigkeit

Unterseeboote mit Uhrwerkbetrieb

Die Unterseeboote sind vollständig wasserdicht abgeschlossen, so daß ein Untergehen unmöglich ist. Ist das Uhrwerk abgelaufen, so bleibt
das Boot an der Wasseroberfläche. Sämtliche Boote sind mit Stützen zum Aufstellen ausgerüstet. Die Boote werden durch ein kräftiges
Uhrwerk rasch vorwärts bewegt und tauchen selbsttätig in regelmäßigen Abständen.

5108
Unterseeboot
mit Uhrwerk
tadellose Schwimm- und Tauchfähigkeit
feststehende Tiefruder
Kommandoturm mit Periskop
5108/23 : 23 cm lang, Laufdauer ca. 2 Minuten
5108/29 : 29 „ „ „ „ 3 „

5081
Unterseeboot
fein geprägter, eleganter Schiffskörper.
Feine Handlackierung, besonders kräftiges und gut regulierbares Uhrwerk, bewegliche Tiefruder an beiden Seiten
Kommandoturm, Periskop, Rettungsboot, Steuerrad, Strecktau
5081/41 : 41 cm lang, ungefähre Laufdauer 5 Minuten
5081/57 : 57 „ „ „ „ „ 6 „

77

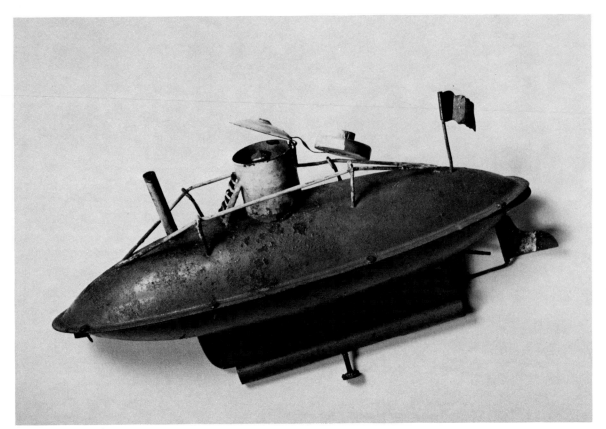

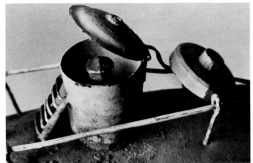

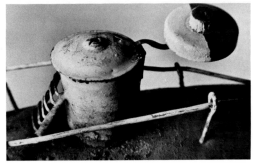

France 8-1/2" 22 cm.

Curiously named the *Berrob* this sub dives when put in water and rises when air from an attached bulb (missing) is squeezed into a rubber tube inside the sub, forcing the water out. The hatch is hinged with a wooden cap and closes to protect the sailor when the sub descends.

According to Jac Remise, this sub won at the Concours Lepine (see p. 85) and was modelled after the *Goubet* which had trials off Cherbourg in 1890.

N° 48-83N. Sous-Marin " Le Berrob ".
JOUET scientifique et **amusant**, se maintenant à volonté à la surface de l'eau ou en plongée, capot mobile.
Longueur 0ᵐ22... **6.75** | 0ᵐ31............. **9.75**

SPEEDBOATS, ROWBOATS, FLOOR BOATS AND THE REST

S.I.F. (Société Industrielle de Ferblanterie) was founded in 1899, producing at first only clockwork trains. In 1928 the firm became Jouets de Paris and in 1913 they became J.E.P., flooding French toy stores with small boats and submarines. After World War II production of boats, and in particular speedboats, began again. These toys were economical: they were offered at a low price and were quite durable. In 1965 J.E.P. closed their doors.

Ruban Bleu No. 0 JEP 1935 14" 36 cm.

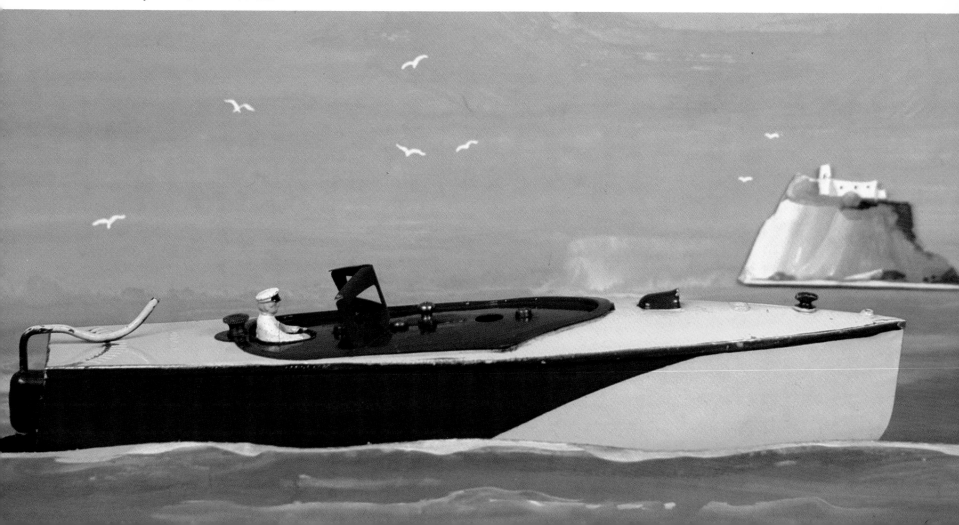

The speedboats of J.E.P. were made from wood until around 1935 when they appeared in metal.

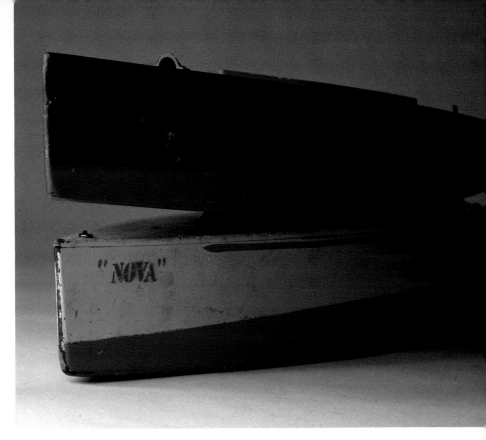

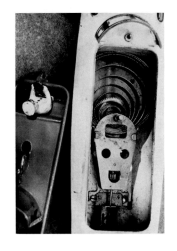

rear to front:
Ruban Bleu No. 0 JEP 14" 36 cm.
Ruban Bleu No. 0 JEP 14" 36 cm.
JEP Ruban Bleu No. 0 12" 30 cm.
JEP Ruban Bleu No. 1 15" 38 cm.
Ruban Bleu No. 1 JEP 15" 38 cm.
JEP Ruban Bleu No. 1 15" 38 cm.
Ruban Bleu No. 2 JEP 20" 51 cm.

Nova 1930 24" 61 cm.
Nova 1930 20" 51 cm.

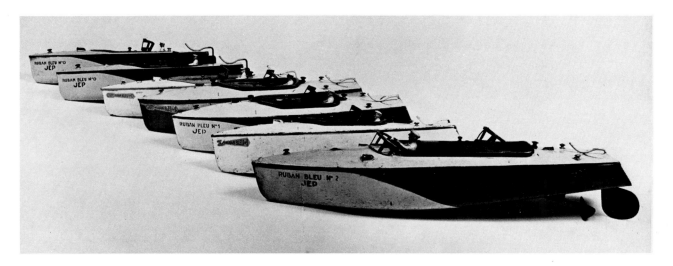

Hornby began production in England around 1907 with the extremely popular Meccano line of toys which were marketed in the US as Gilbert's "Erector Sets." Between the two World Wars Hornby made small clockwork trains. This lovely series of speedboats appeared around 1935.

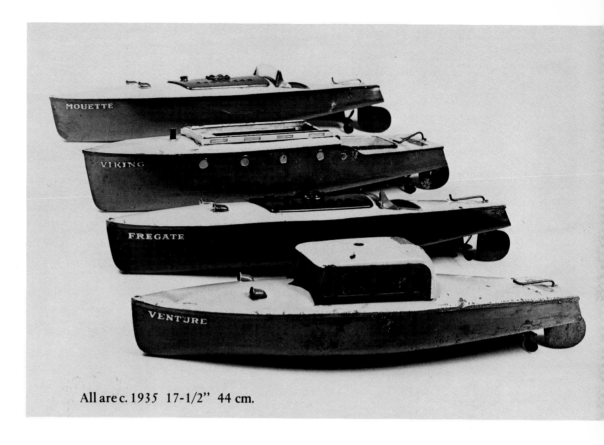

All are c. 1935 17-1/2" 44 cm.

10-3/4" 27 cm. The *Zippee* is powered by a balloon attached to the long tube at the stern.

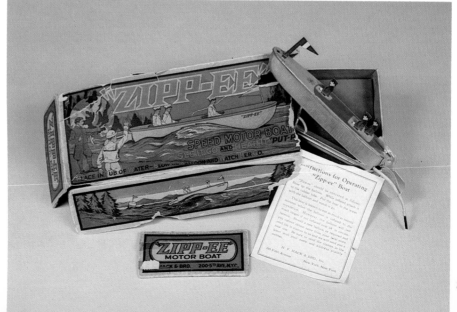

Bing 1910 8-1/2" 22 cm. This speedboat was offered in the US by Sears, Roebuck & Co. in 1912 for 79¢.

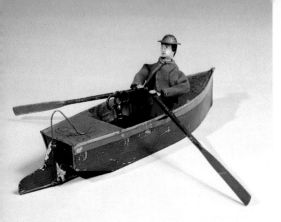

Ives *Carrie* 1869 10-1/2" 27 cm. The *Carrie* is also known at the "Warner single oarsman," after its inventor; see the Patent Gazette illustration of his marvelous innovative toy.

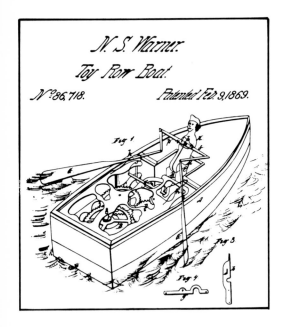

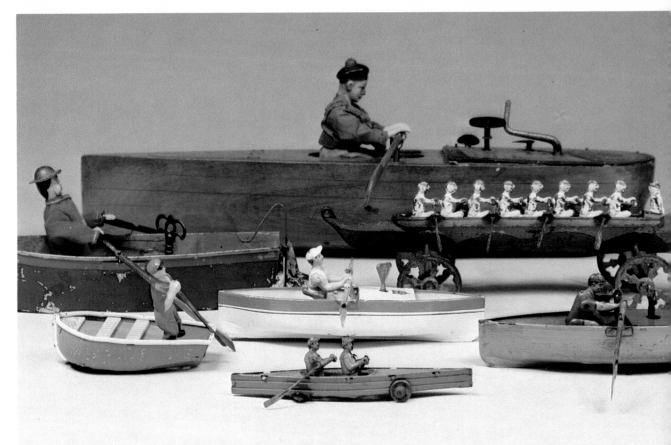

front: Germany 1890 6-1/2" 17 cm; 2nd row: 5" 13 cm; Arnold 1950 8-1/2" 21 cm.; Arnold 1920 8-1/2" 21 cm.; 3rd row: see left; American Mechanical Toy Co. 14" 36 cm.; rear: France *Automatic Rower* 22-1/2" 57 cm.

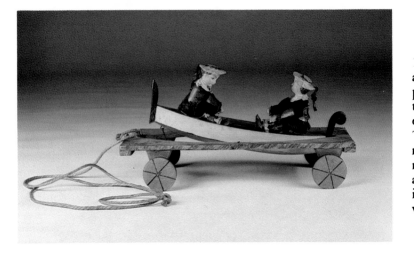

12-3/4" 32 cm. While at first appearing a bit rough for a production piece, this pull toy is on closer inspection extremely well put together. The rocking and rowing mechanism seems too simple not to have been used often, and the identical sailor boys indicate that many of them were made.

At the turn of the century in Paris, contests were held for toy inventors at which they could display their latest ideas for toy company representatives. The manufacturers would make awards for the best toy and thereby practically assure the inventor that his toy would be purchased and produced. In the summer of 1906, the Sixth Lepine Contest (the Concours Lepine) in the prefecture of Paris was held and proved to be the most conclusive, most important of all the other annual contests. Two new toys emerged that year taking top prizes: the *Accident Automobile* which fell apart when it hit an obstacle; and the *Automobile Boat*, the *Amphibo*, from a Monsieur Gremillet, which soon appeared in production made of metal and wood and driven by a rubber band. The one illustrated here is extraordinary because it is in such pristine original condition. Other manufacturers of toys such as Bing and Plank also made these popular craft.

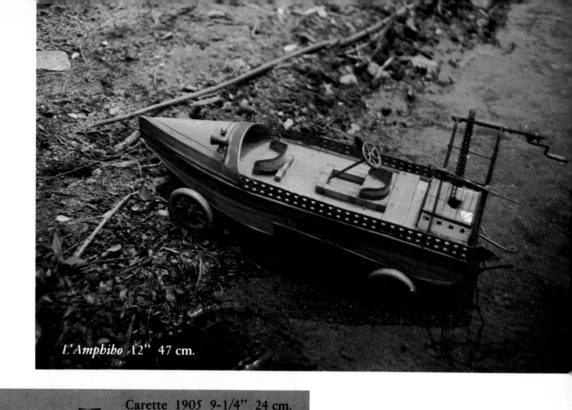

L'Amphibo 12" 47 cm.

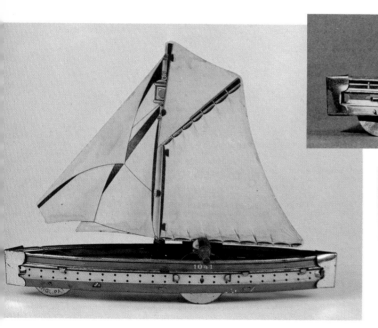

Carette 1905 9-1/4" 24 cm.

Carette 1905 9-1/4" 24 cm. This sailboat, sporting a printed paper sail, and the gunboat work on a friction or inertia motor and have an off-center wheel in the bow that gives the boats a rocking motion as they sail along the floor. These are similar in action to boats offered by Hess on pp. 90-1.

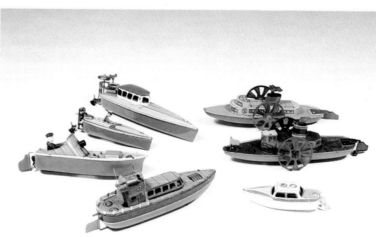

clockwise from front left: Arnold 1920 9" 23 cm.; 7" 18 cm.; US Zone Germany 11" 30 cm.; England 10" 25 cm.; Kellerman 10" 25 cm.; US Zone Germany 5" 13 cm. An ensemble of various small boats. The first two have flint and steel sparking mechanisms; the smallest of the group is a tiny "putt-putt."

85

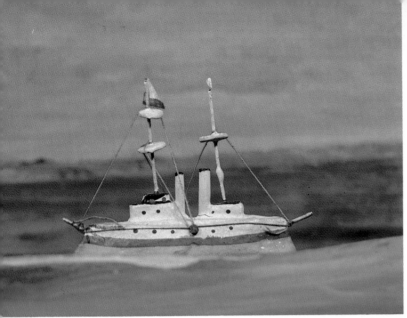

3-1/2" 9 cm.

Falk as well as Carette produced these lovely tiny boats made of tin and lead. On p. 88 is one of Falk's finest: even the sails are of tin. To the left is a composition boat from an early series made to commemorate the resounding Japanese defeat of the Russian fleet in 1904.

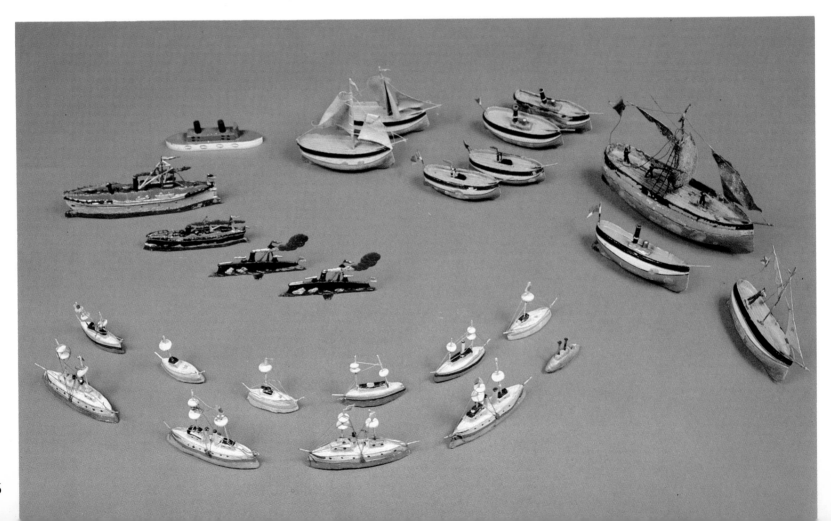

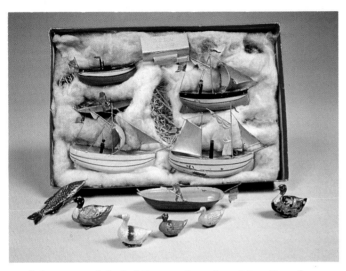

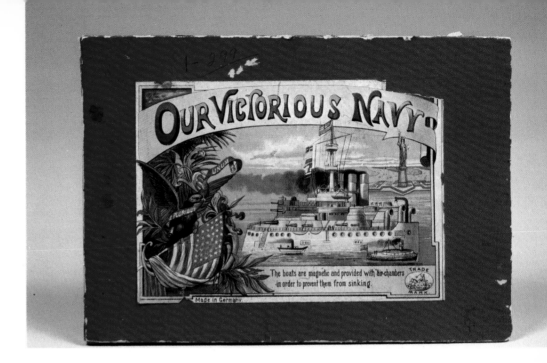

Both boxes are labeled "Our Victorious Navy" and were intended for the U.S. market.

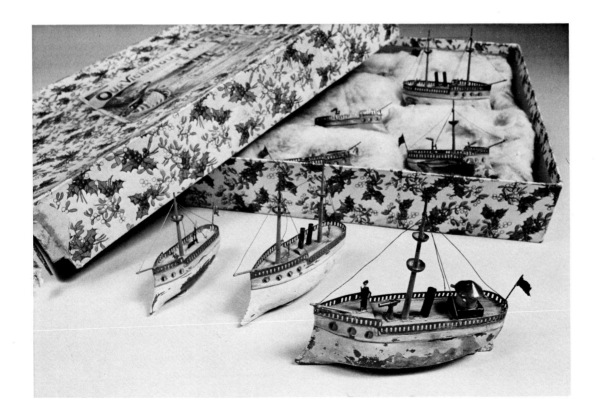

Uebelacker 1900 4" 10 cm.; 4-1/2" 11 cm.; 5-1/2" 14 cm. Though trademarked Uebelacker, these small boats are identical to those from Falk.

overleaf: Falk 6" 15 cm.

87

This charming warship like the Noah's Ark on p. 43 are of lithographed tin. Toy collectors once scorned tin litho toys but now regret having done so, for choice examples of this tinsmith's art are rare. Copying them now would be impossible (unlike the reproduction possibilities of most of the other boats in the book) because these tin masterpieces are made with a florid yet flatly simple freshness that is extraordinary.

11" 28 cm. Like the papier-mâché boat on p. 86, this spring-wound gunboat celebrates the Japanese victory over Russia in 1904. Better handling of fewer, more modern ships by Admiral Togo obliterated the Russian fleet and thrilled a world ever ready for new heroes.

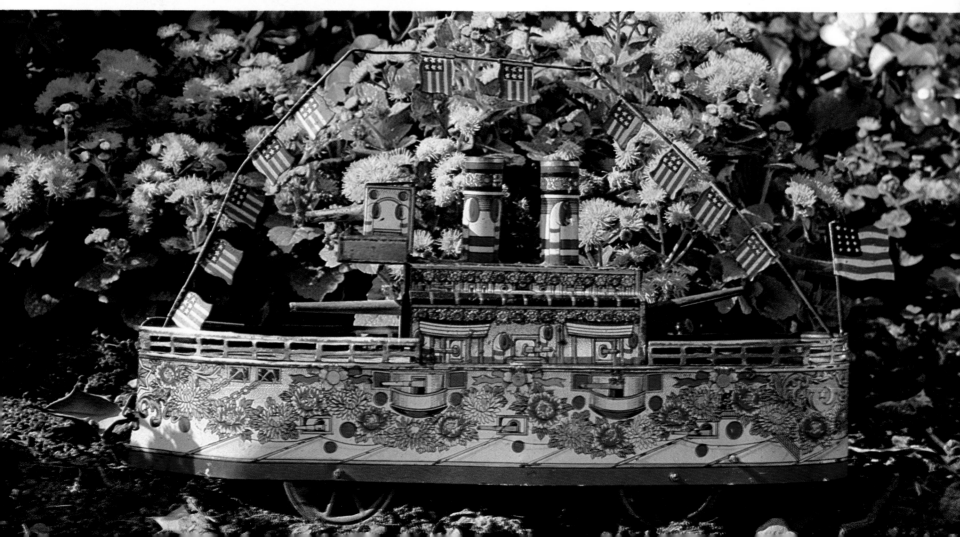

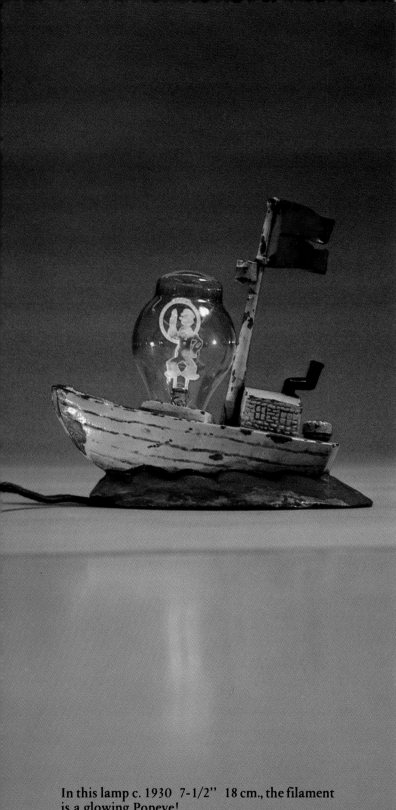

In this lamp c. 1930 7-1/2" 18 cm., the filament is a glowing Popeye!

Hess 11-1/2" 29 cm.; 9-3/4" 25 cm.

"Young Navigators" G.H. Boughton 1870

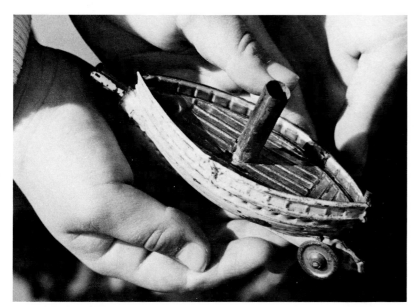

A penny toy 1900 4" 10 cm.

Hess 1910 The flagship is 8" 20 cm.
and the rest are 5-1/2" 14 cm.
In excellent condition, the fleet
is missing the small rods that
connect the small ships to the
wind-up dreadnought.

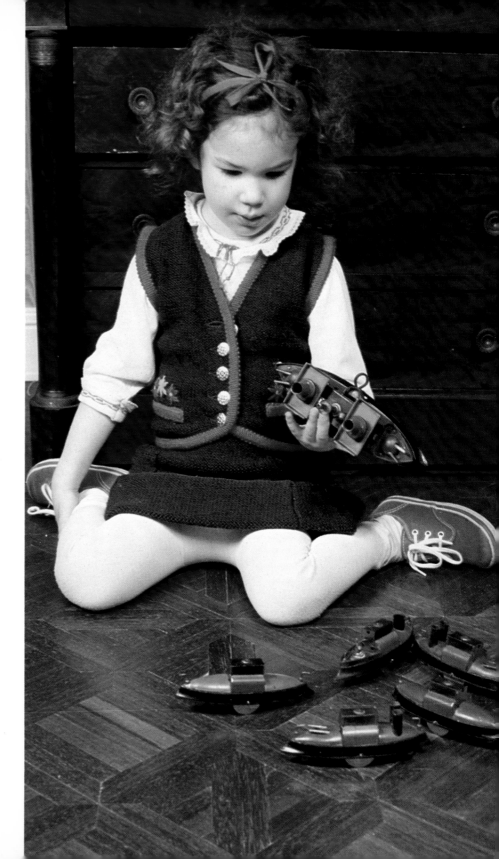

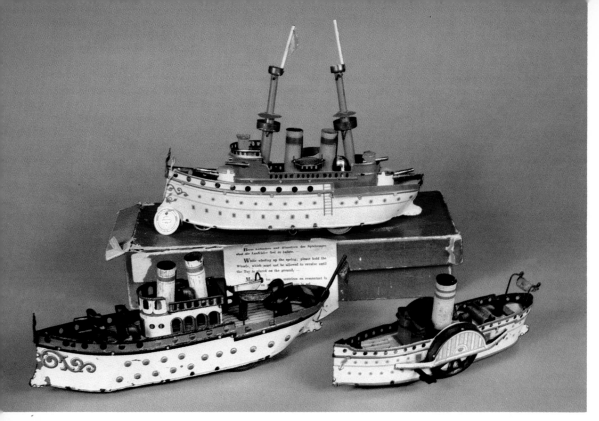

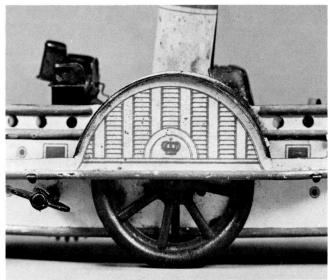

Oro 11" 28 cm.; 11" 28 cm.; 8-1/2" 22 cm.

👉 Sailor bell toy: Watrous Mfg. Co.
9" 23 cm.; diver: Germany 7" 18 cm.

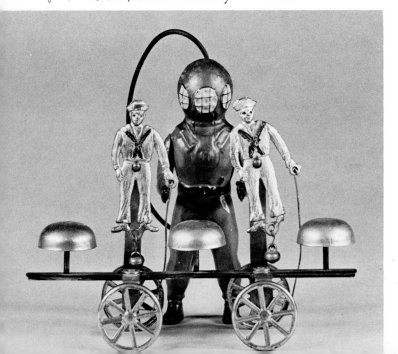

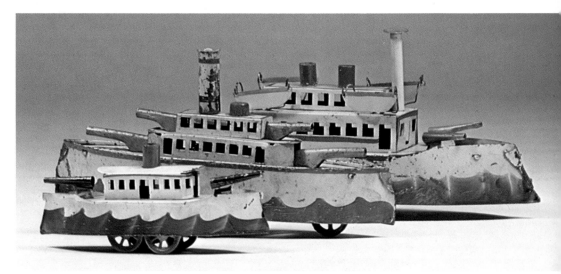

US battleships from the Dayton Friction Toy Co.,
front to rear: 10" 25 cm.; 15" 38 cm.; 18" 46 cm.

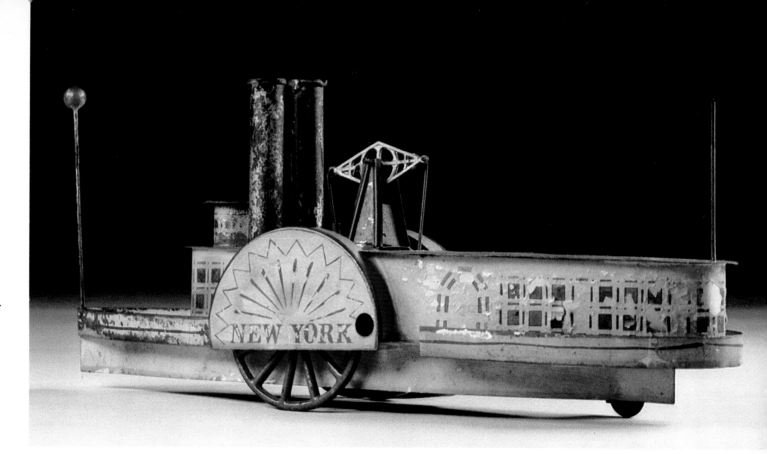

Brown, or Brown and Stevens *New York* 1860 or 1870 13-3/4" 35 cm.

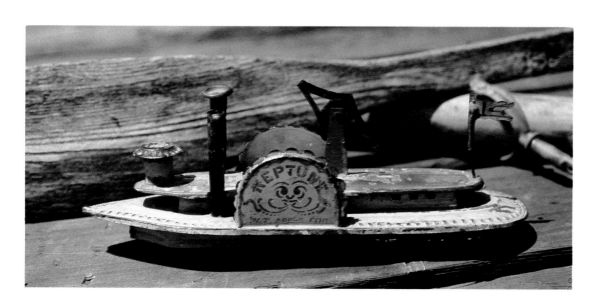

James Fallows & Co. *Neptune* 11-1/2" 29 cm. The riverboat was a popular theme for toys in the U.S. and versions were made by many toy companies of the day. This one is marked with the clever Fallows phonetic, "IXL" (I excel).

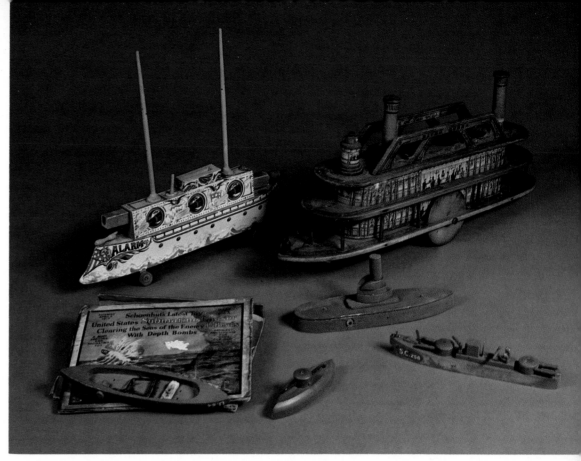

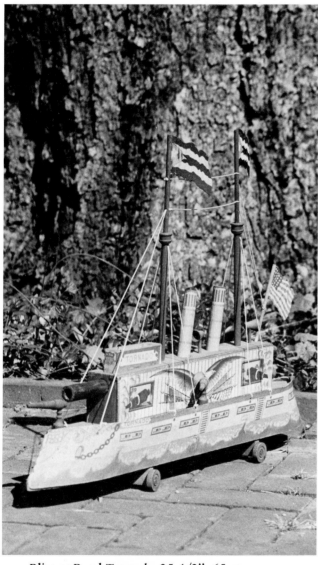

Bliss or Reed *Tornado* 25-1/2" 65 cm.

left: The *Alarm*, 17" 43 cm., has a rubber band-powered cannon that shoots wooden bullets. right: 25-1/2" 65 cm. This American paper and wood boat from about 1870 has a reversible name plate to suit the captain's whim: *River Queen* or *Gem of the Ocean*. front: Schoenhut's toy torpedo and exploding ship set works on the spring-snapped mousetrap principle.

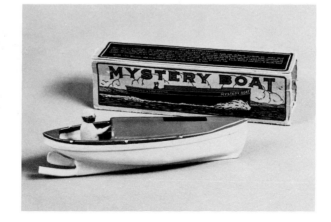

Gobar Products
Mystery Boat 1921
9" 23 cm. Another boat with "putt-putt" propulsion, the box extolls it as "Realistic, Educational, Mysterious, the World's Greatest Toy."

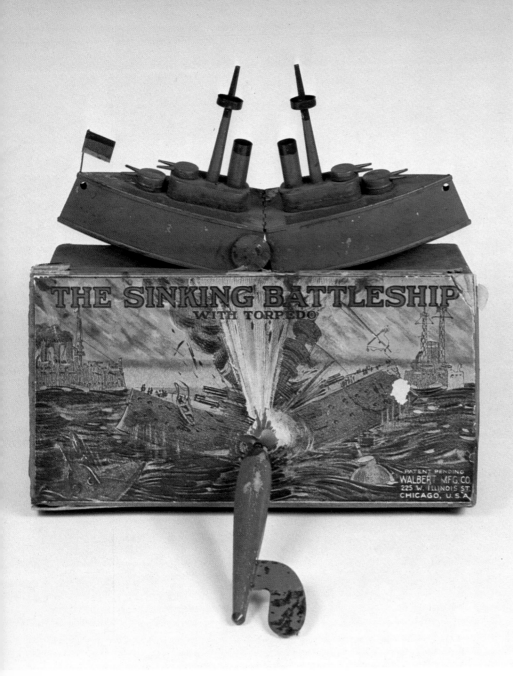

Walbert Mfg. Co. *The Sinking Battleship* 13-1/2" 34 cm.
When the rubber band-wound torpedo strikes the button the
ship splits and sinks.

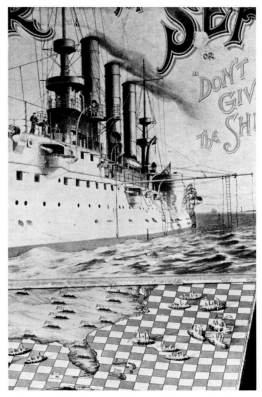

McLoughlin Bros. *War at Sea* or *Don't
Give Up the Ship* 1898

Boats with their original boxes are even harder to find, as most toys were not always carefully put away. The boxes are helpful for positive identification, but more than that they provide a truer idea of what a child's delight might have been when such a present was received and opened.

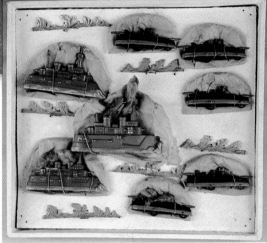

The *Panzerflotte* is from the famous German miniature soldier manufacturer of Heyde. The largest ship is 5" 13 cm., the smallest is 3" 8 cm. Note the blackened cotton puffs used for smoke.

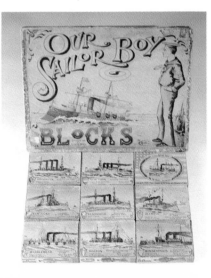

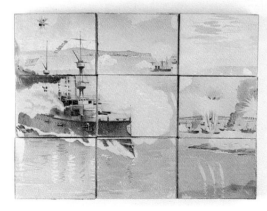

R. Bliss Mfg. Co. 1899
Our Sailor Boy Blocks

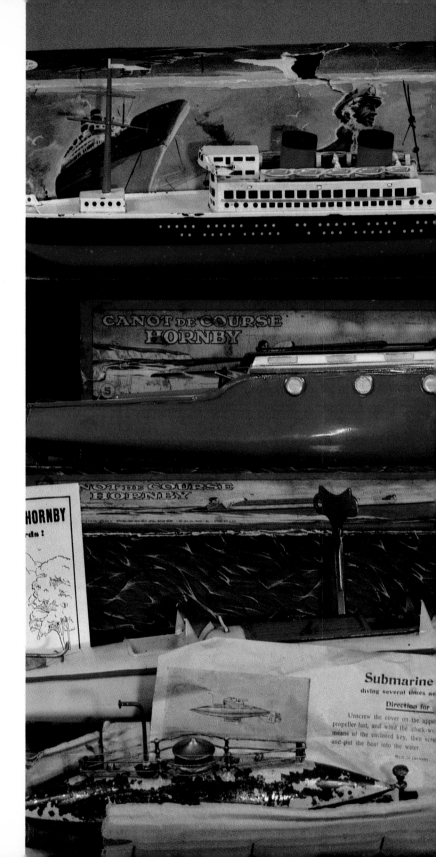

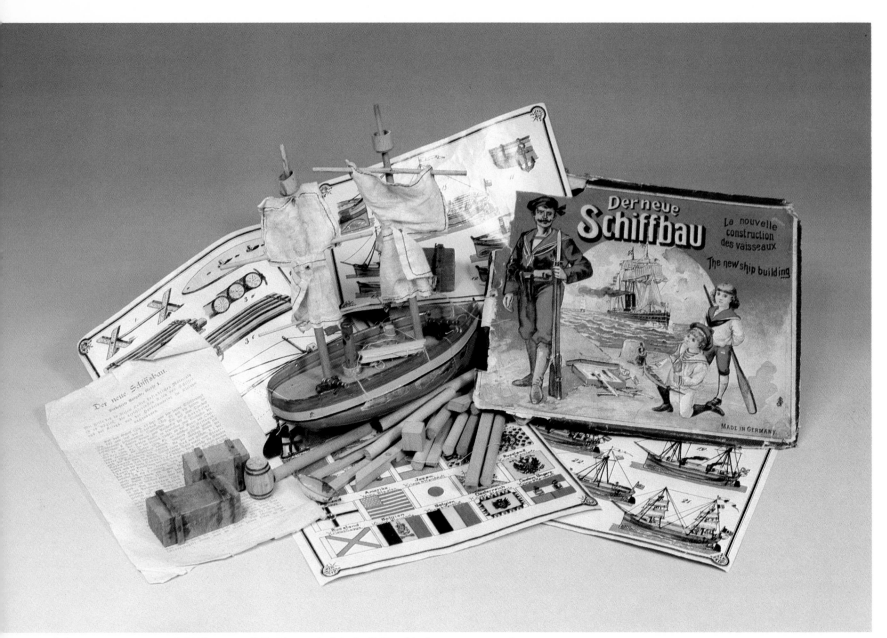

Schoenner *Der Neue Schiffbau* 8-1/2" 22 cm. A ship building kit for war or merchant activities, complete with flags of all nations and many design possibilities.

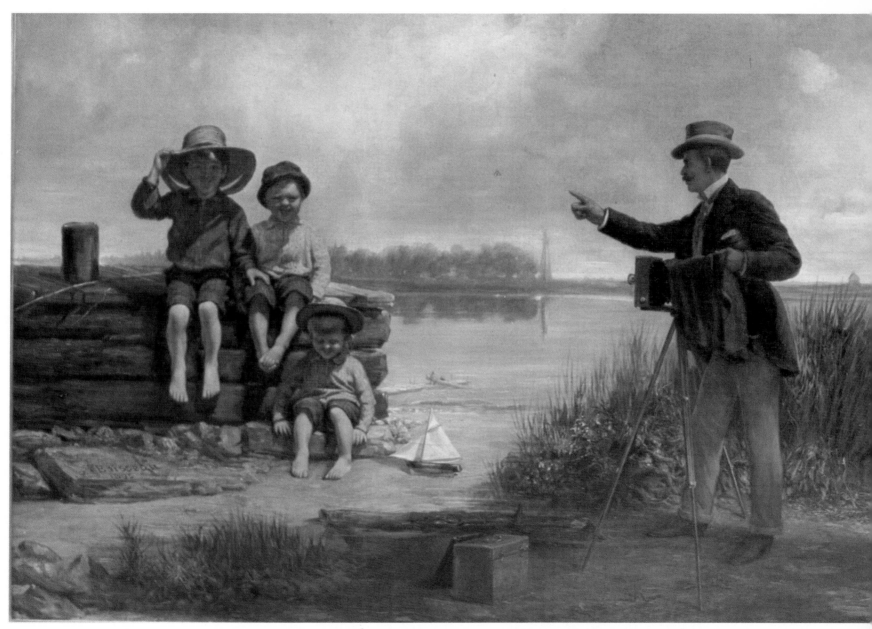

"The Photographer" Alfred Boisseau late 19th Century

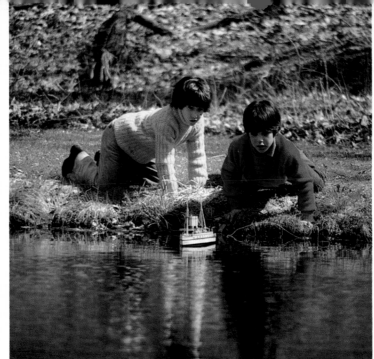
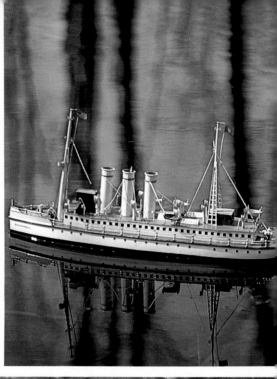
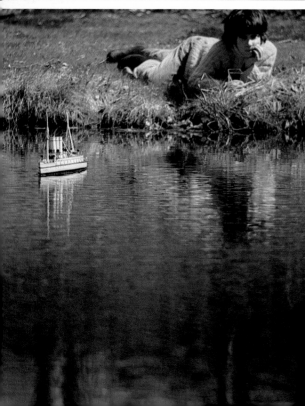
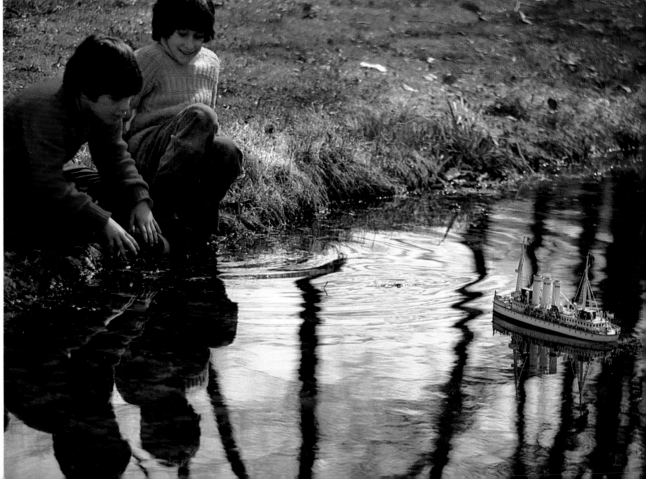

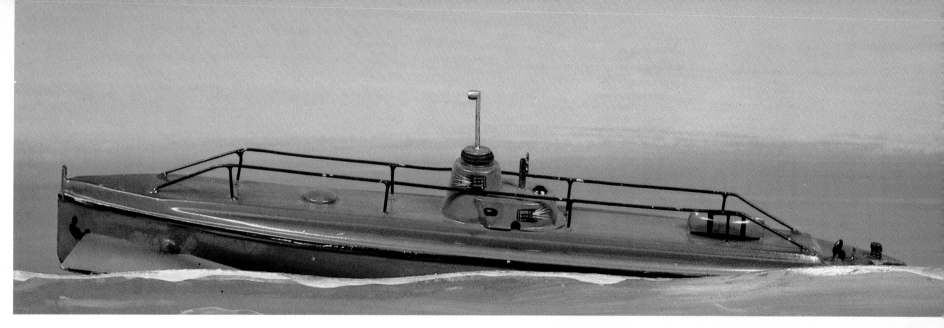

Drawing by Chas. Addams; © 1950, 1978 The New Yorker Magazine, Inc.

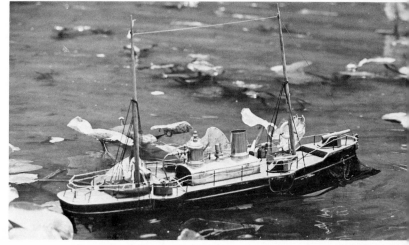

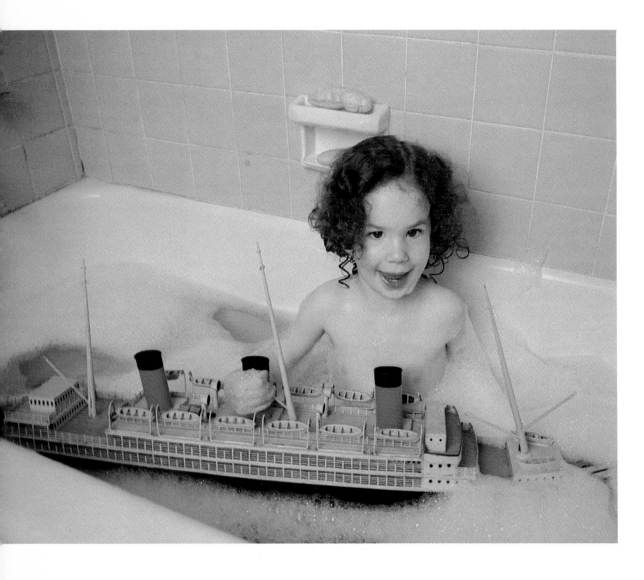

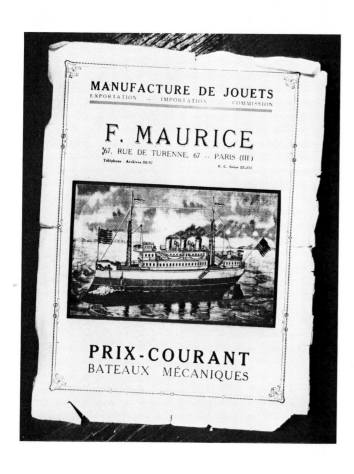

MANUFACTURE DE JOUETS
EXPORTATION -- IMPORTATION -- COMMISSION

F. MAURICE

67, RUE DE TURENNE, 67 -- PARIS (III)

Téléphone : Archives 00-97 R. C. Seine 25,321

PRIX-COURANT
BATEAUX MÉCANIQUES

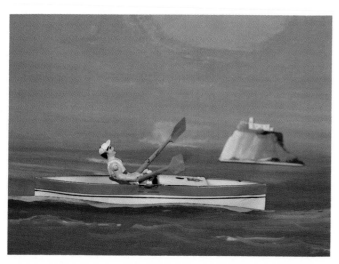

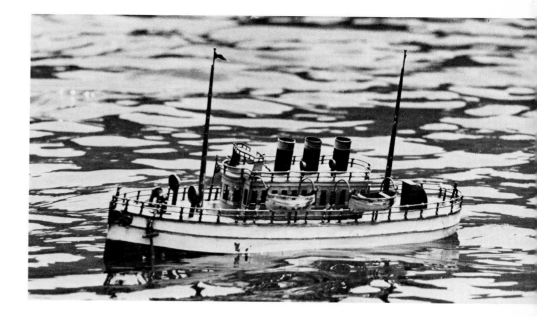

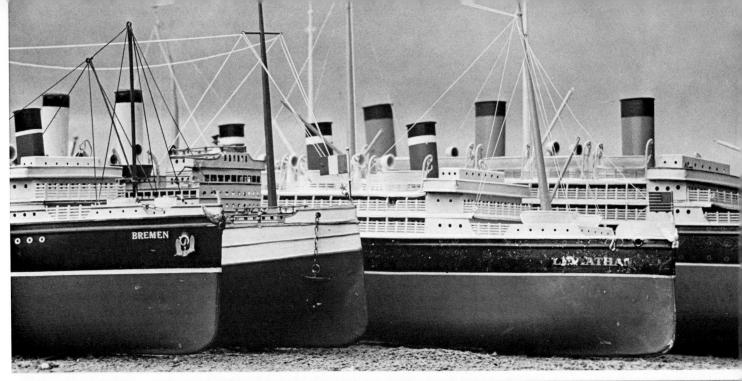

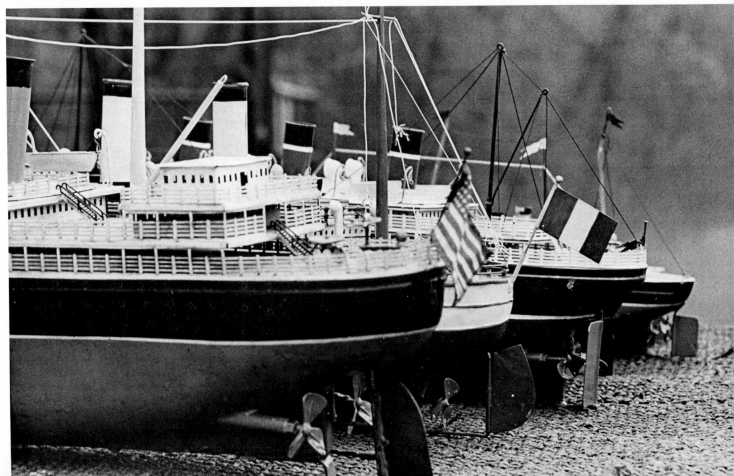

Index

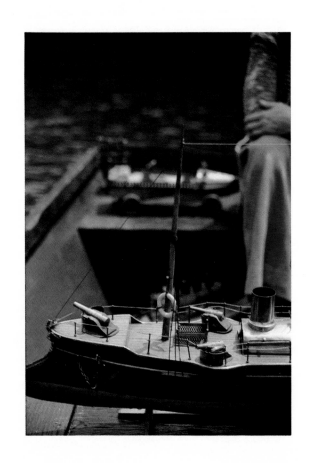

Bibliography

d'Allemagne, Henri: *The World's Fair St. Louis USA 1904*, France

Les Jouets, Hachette, France, 1900

Althof, Bergman & Co., Illustrated Catalogue of Tin and Mechanical Toys Manufactured by; 1874 catalogue re-issued by Antique Toy Collectors of America, 1975

Anderson, Curtiss: *Jerry Smith's Collections from the American Past*, Hallmark Cards, USA, 1976

Annuaire des Fabricants de Jouets, France, 1890

Baecker, Carlernst, and Haas, Dieter: *Die Anderen Nürnberger Vols. 1-5*, Verlag Eisenbahn, Germany, 1973-76

Carette, Georges, The Great Toys of, Allen Levy, Ed.; New Cavendish Books, England, 1975

Claretie, Leo: *Les Jouets de France*, Delagrave, France, 1920

Franzini, Paolo, and Dellanzo, Luisa: *Quel Mondo Dipinto*, Italy, 1978

Fraser, Antonia: *A History of Toys*, Weidenfeld & Nicholson, England, 1966

Freeman, Larry and Ruth: *Cavalcade of Toys*, Century House, USA, 1942

Grober, Karl: *Kinderspeilzug aus alter Zeit*, Germany, 1928

Harman, Kenny: *Comic Strip Toys*, Wallace-Homestead Book Co., USA, 1975

Hertz, Louis: *The Toy Collector*, Funk & Wagnalls, USA, 1969

Hill, N.N., Brass Co. and Watrous Mfg. Co. Illustrated Catalogue of Bells and Toys; 1905

catalogue re-issued by Ben and Carol Nelson, USA, 1974

Hillier, Mary: *Automata & Mechanical Toys,* Jupiter Books, England, 1976

Jeanmaire, Claude: *Bing Bros.—Toys Manufactured 1902-1904: Archiv Nr. 28*, Verlag Eisenbahn, Switzerland, 1974

Bing Bros.-Toys Manufactured 1912-1915: Archiv Nr. 29, Verlag Eisenbahn, Switzerland, 1977

Toys of Nuremberg: Jean Schoenner's Toy Railways and Ships: Archiv Nr. 100, Verlag Eisenbahn, Switzerland, 1977

and Haas, Dieter: *Marklin Vols. 1 & 2*, Hobby Haas, Germany, 1975, 1976

Kimball, Ward: *Toys: Delights from the Past*, Applied Arts Publishers, USA, 1976

King, Constance Eileen: *The Encyclopedia of Toys*, Crown, USA, 1978

Long, Earnest and Ida: *Dictionary of Toys Sold in America, Vols. 1 & 2*, USA, 1971, 1978

Marklin & Cie: Hauptkatalog P 19; catalogue re-issue

Marklin, Jouets; 1922 catalogue re-issued by "L'Automobiliste", France

Maillard, Rabecq: *Histoire du Jouet*, Hachette, France, 1962

Milet, Jacques: *Les Bateaux Jouets*, A. Maeght, Ed.; France, 1960

Miller, Byron S.: *Sail, Steam, and Splendour*, N.Y. Times Books, USA, 1977

Newell, Gordon: *Ocean Liners of the 20th Century*, Bonanza Books, USA, 1963

O'Brien, Richard: *Collecting Toys*, Books Americana, USA, 1979

Perelman, Leon J.: *Perelman Antique Toy Museum*, USA, 1972

Plank, Ernst: Nurnberg: Katalog Ausgabe E.P. 1903, Jan Blenken, Rolf Richter, Reinhard Rossig, Eds.; Weinheimer Auktionshaus, 1973

Pressland, David: *The Art of the Tin Toy*, Crown, USA, 1976

Remise, Jac: *L'Argus des Jouets Anciens 1850-1918*, Balland, France, 1978

and Fondin, Jean: *The Golden Age of Toys*, Edita, Switzerland, 1967

Schwartz, Marvin: *F.A.O. Schwartz Toys through the Years*, Doubleday & Co., USA, 1975

Stevens, J.E., Bank Catalogue Sheets; re-issued by Bruce C. Greenberg, 1974, USA

White, Gwen: *Antique Toys and Their Background*, Arco, USA, 1971

Wonderful World of Toys, Games & Dolls: 1860-1930, Joseph J. Schroeder, Jr., Ed.; Digest Books, USA, 1971

Publications

Antique Toy World, Dale Kelley, Pub. and Ed.; monthly, USA

Old Toys, Arno Weltens, David Symonds and Carol Ann Stanton, Eds.; monthly, England

The Toy Chest, The Antique Toy Collectors of America, monthly, USA

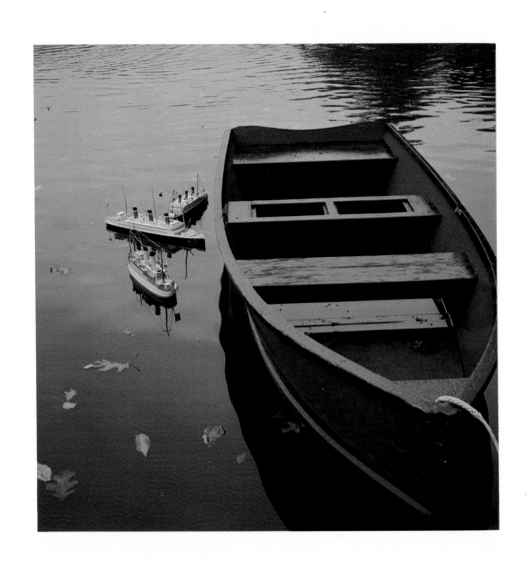